CHERRY BLOSSOM TIME IN JAPAN THE COMPLETE WORKS

LEE FRIEDLANDER

FRAENKEL GALLERY

TO THE MEMORY OF SHOJI YAMAGISHI

Were there no cherry-blossoms
In this world of ours,
The hearts of men in spring
Might know serenity.

世の中にたえて櫻のなかりせば

春の心はのどけからまし

WAKA OF NARIHIRA, 825–880

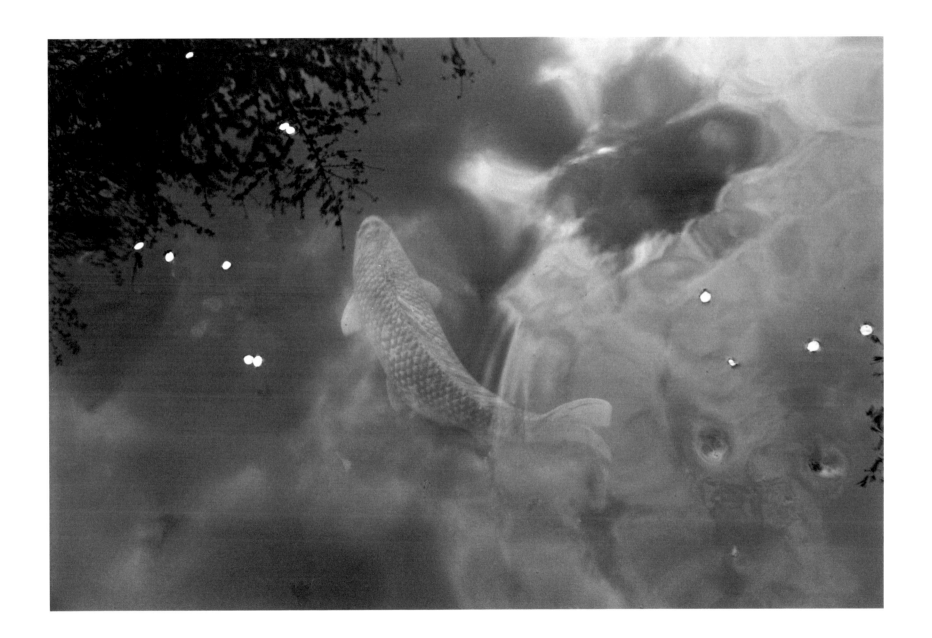

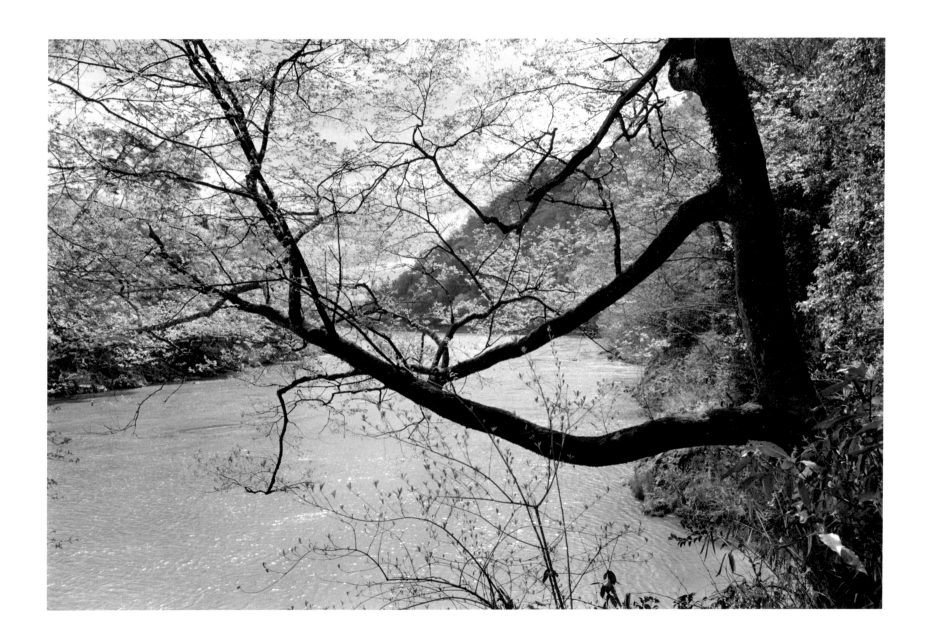

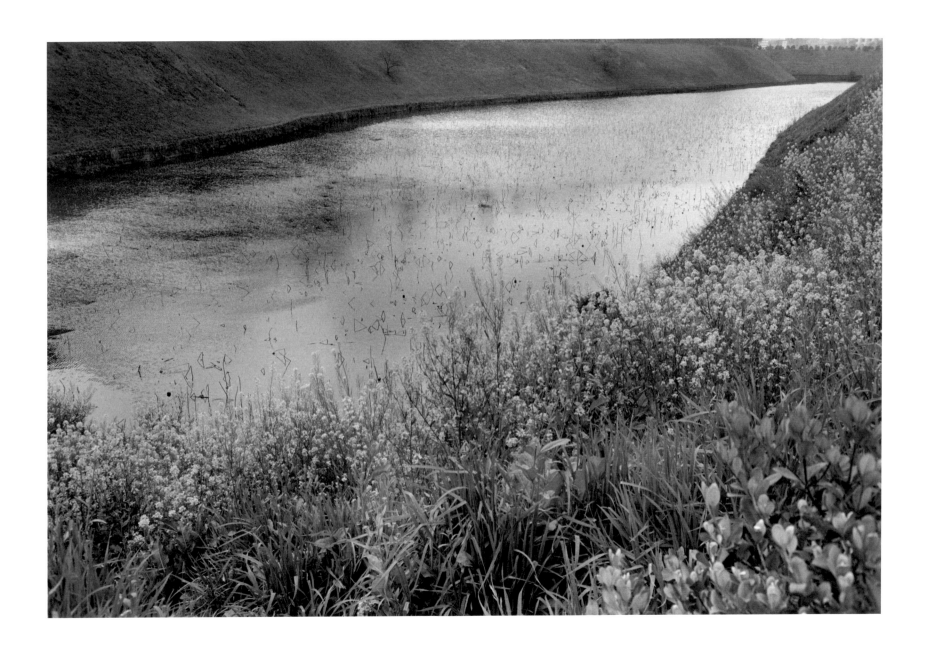

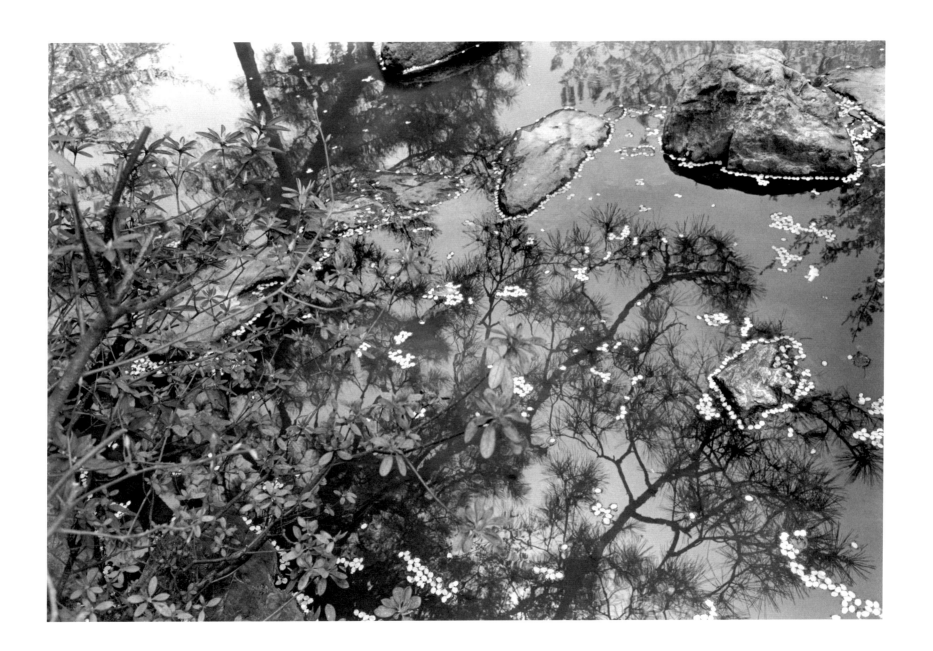

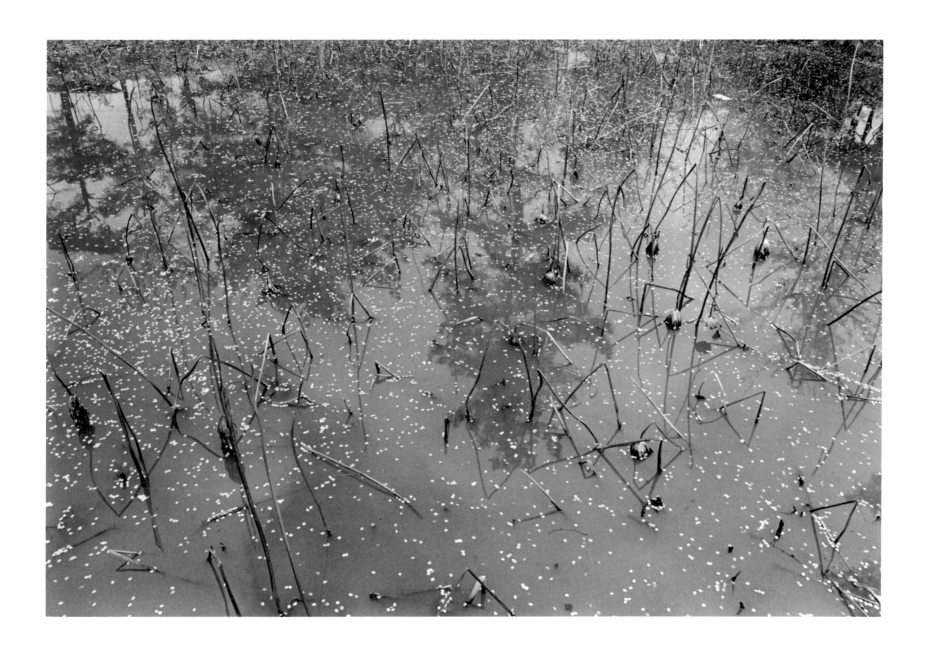

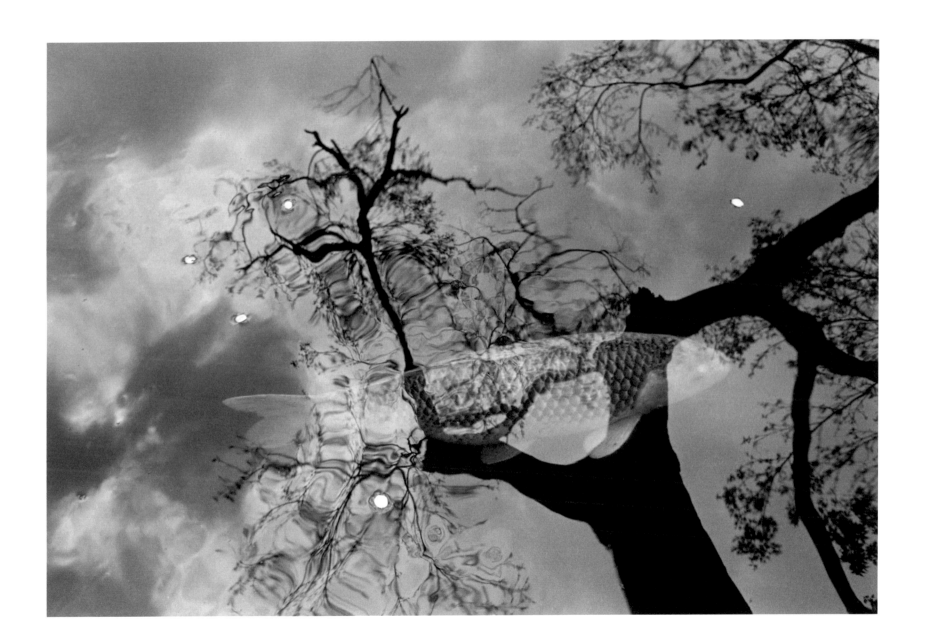

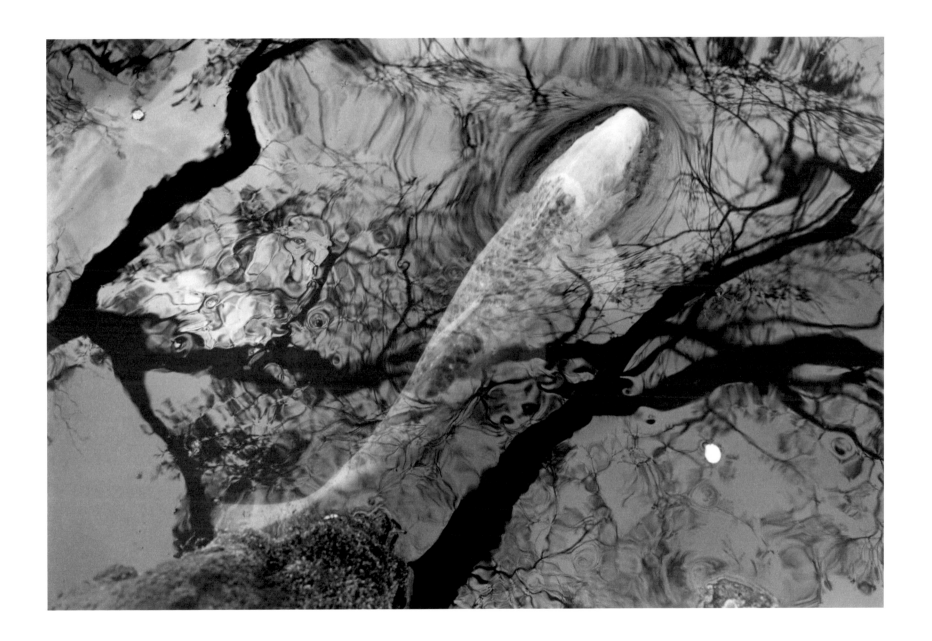

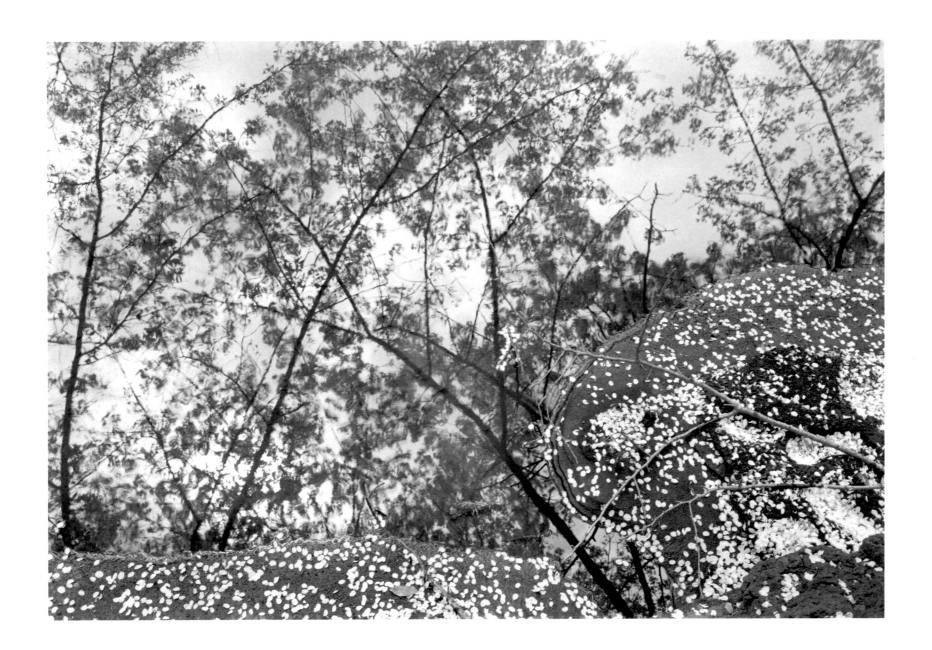

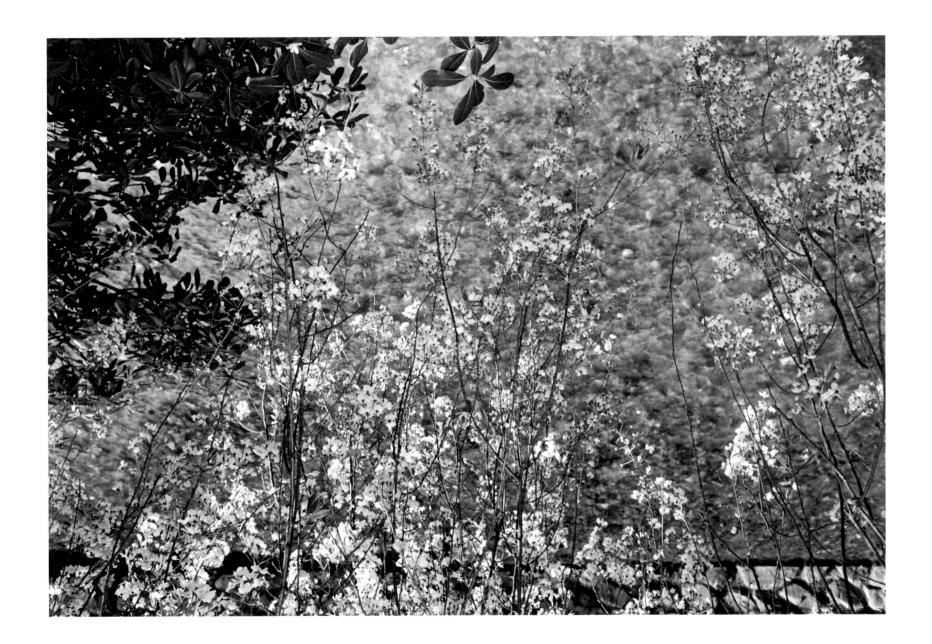

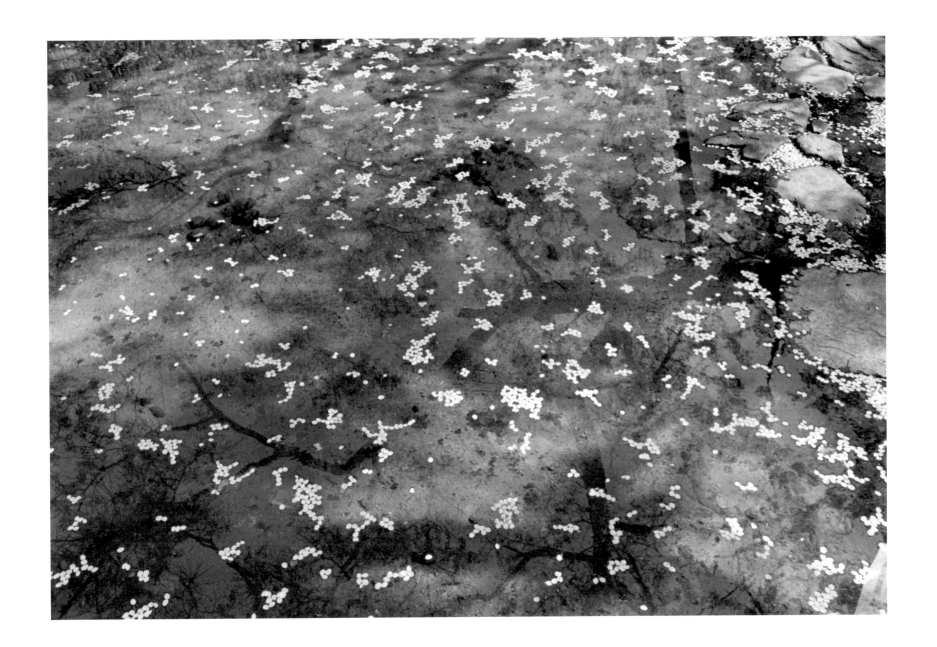

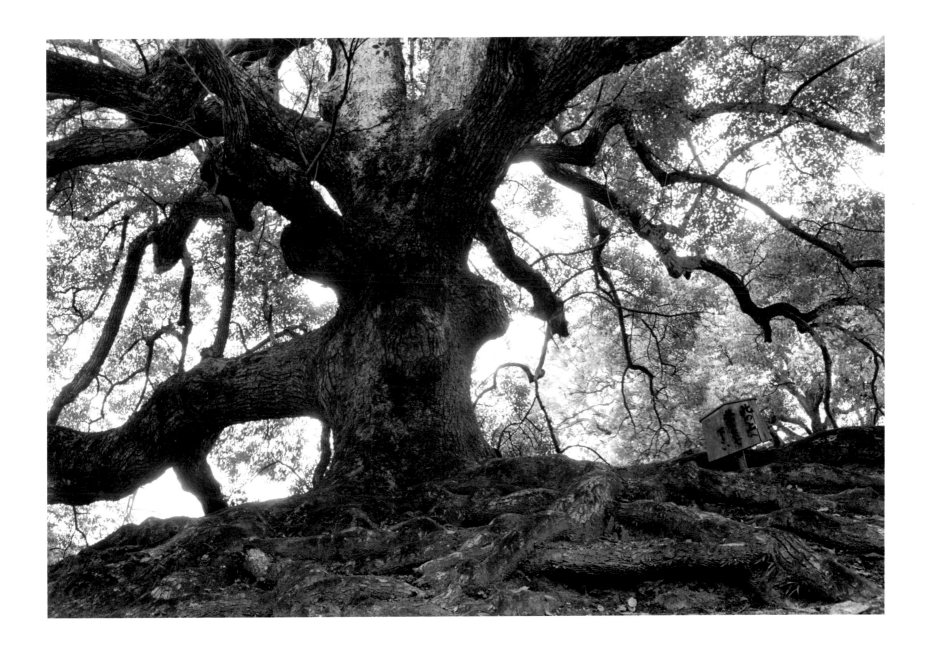

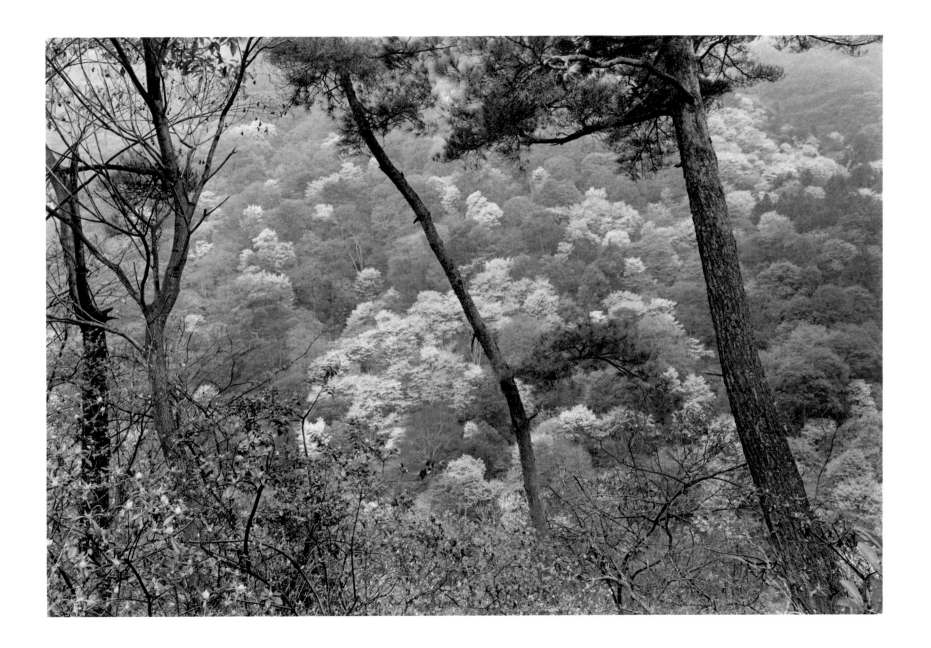

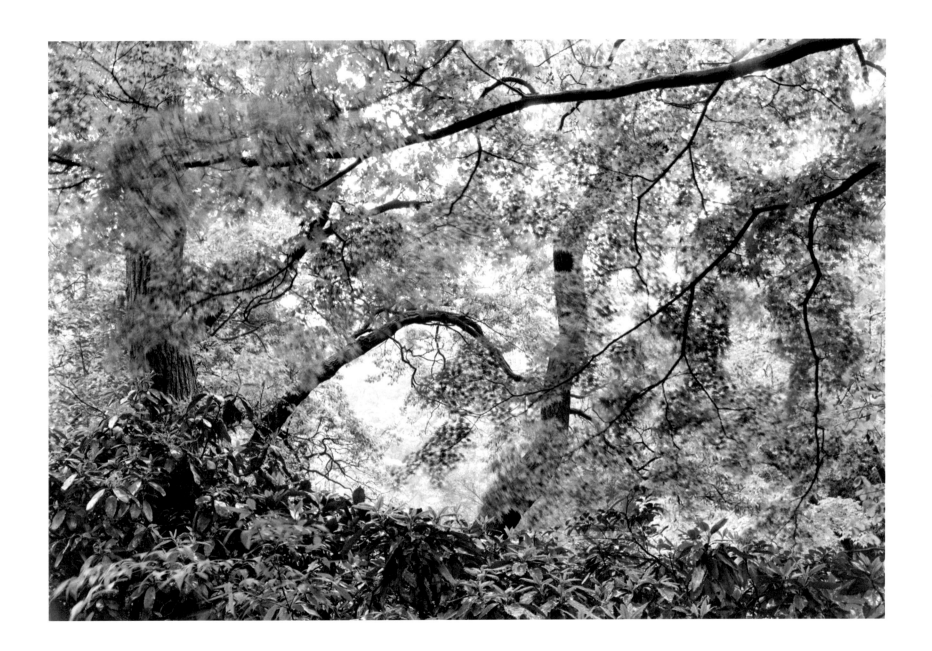

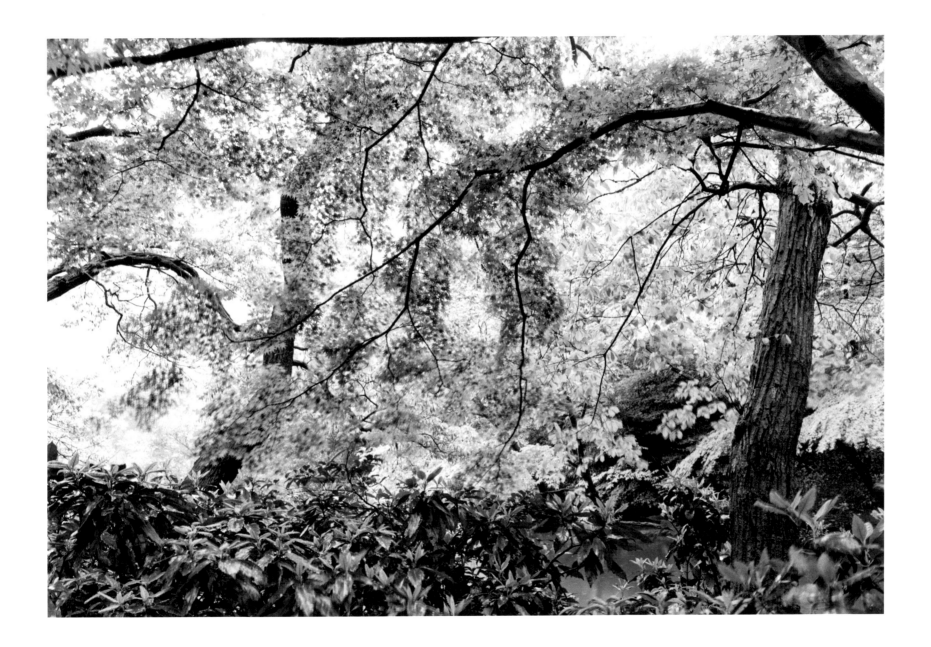

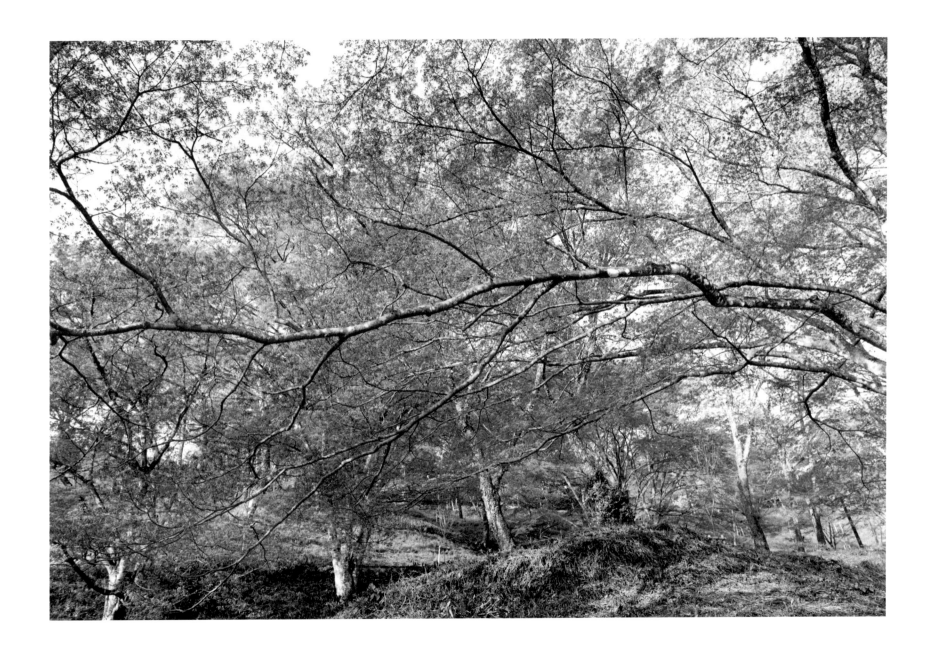

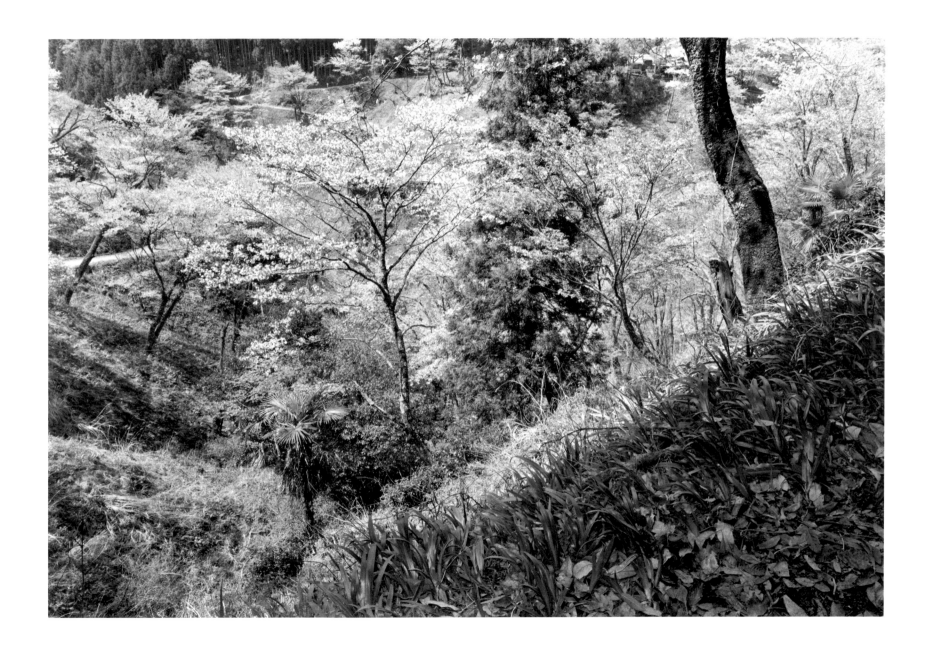

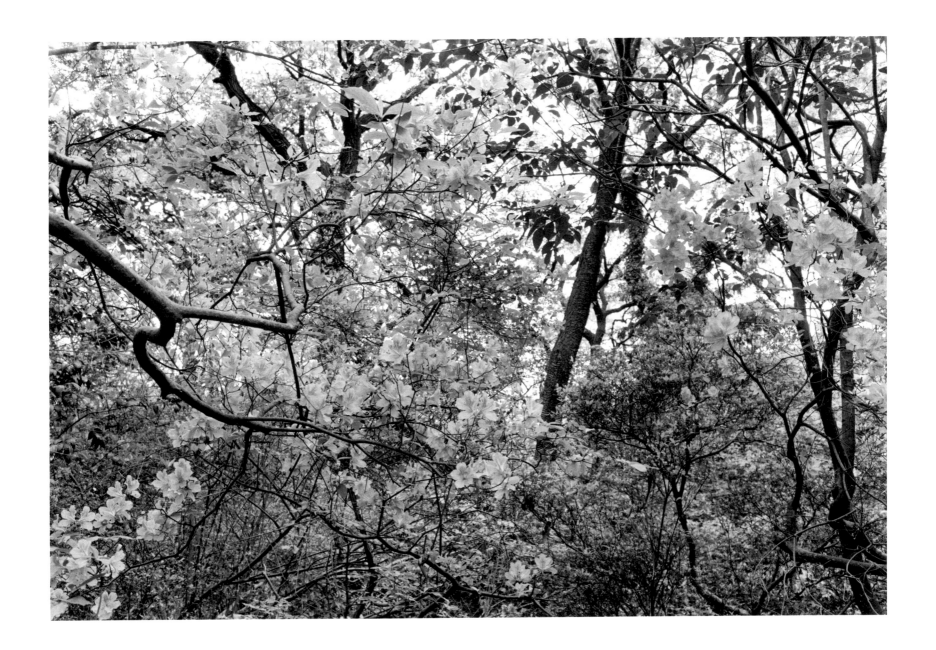

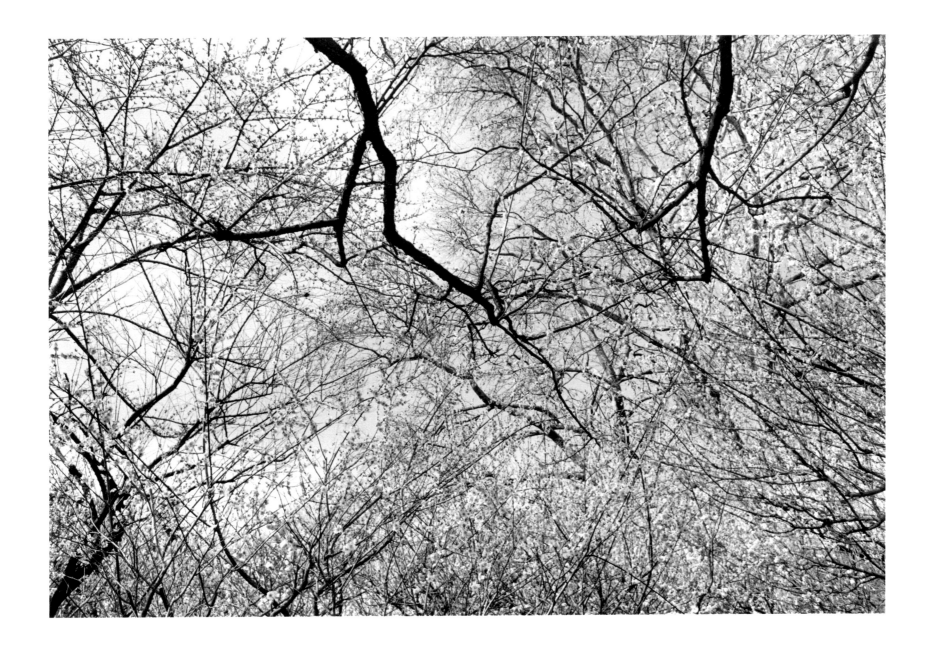

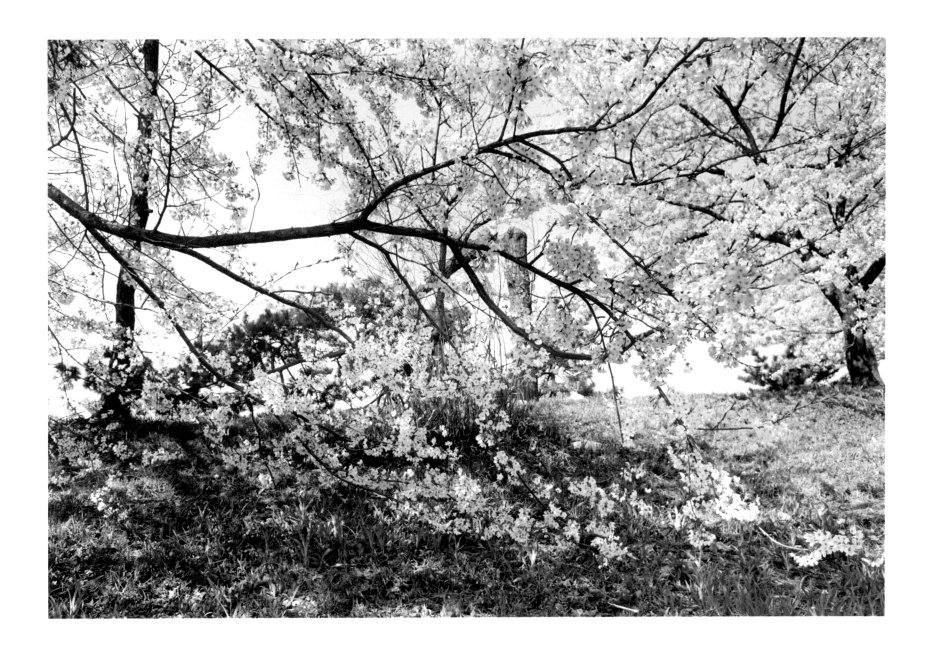

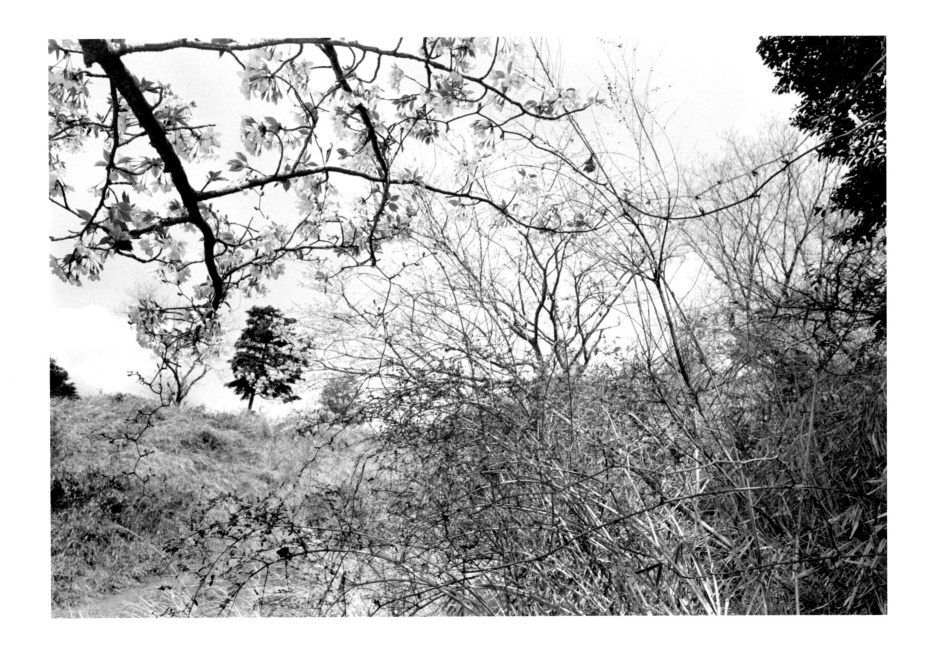

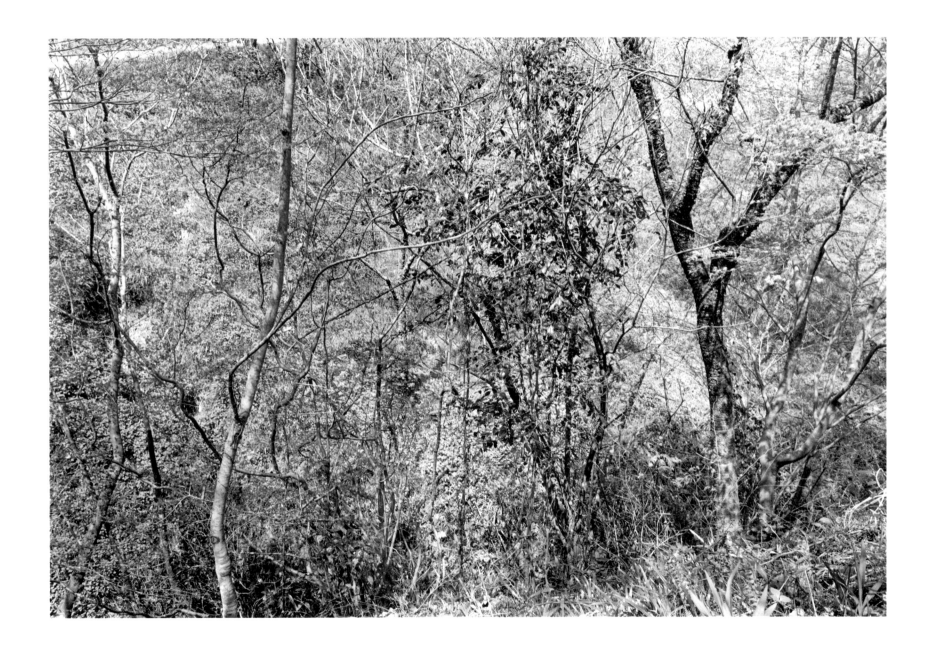

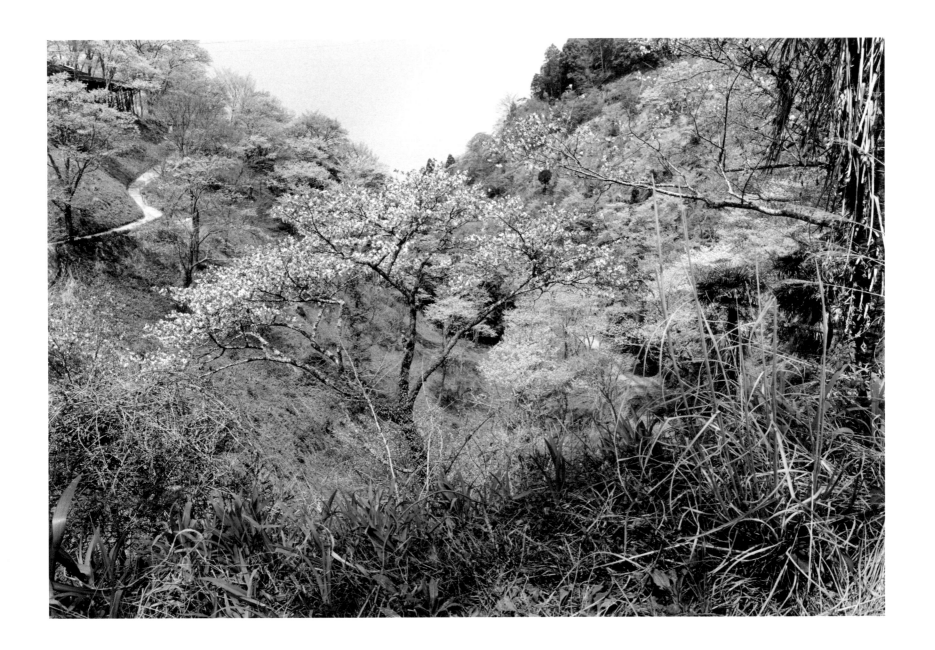

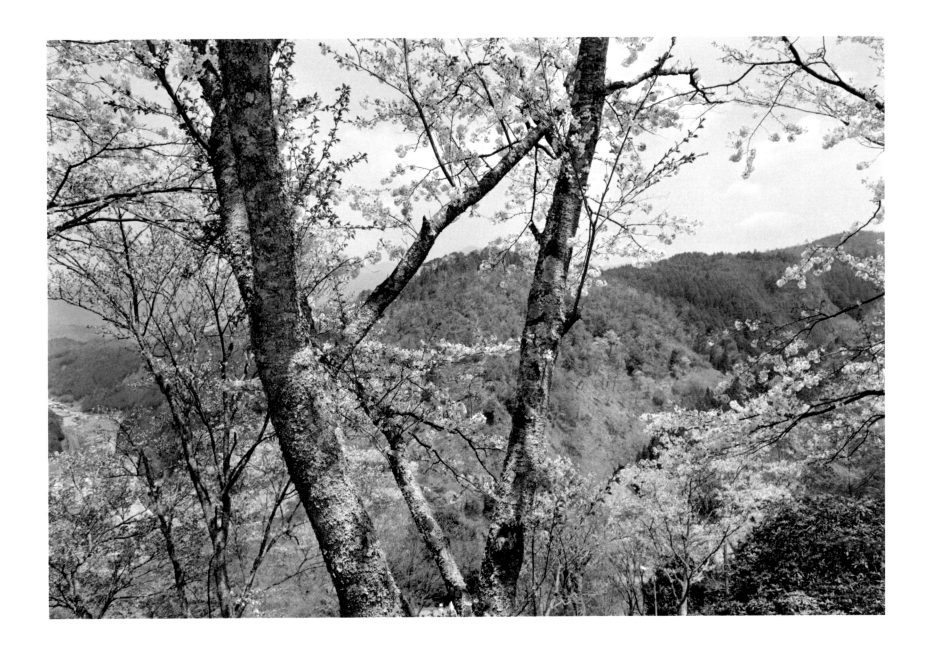

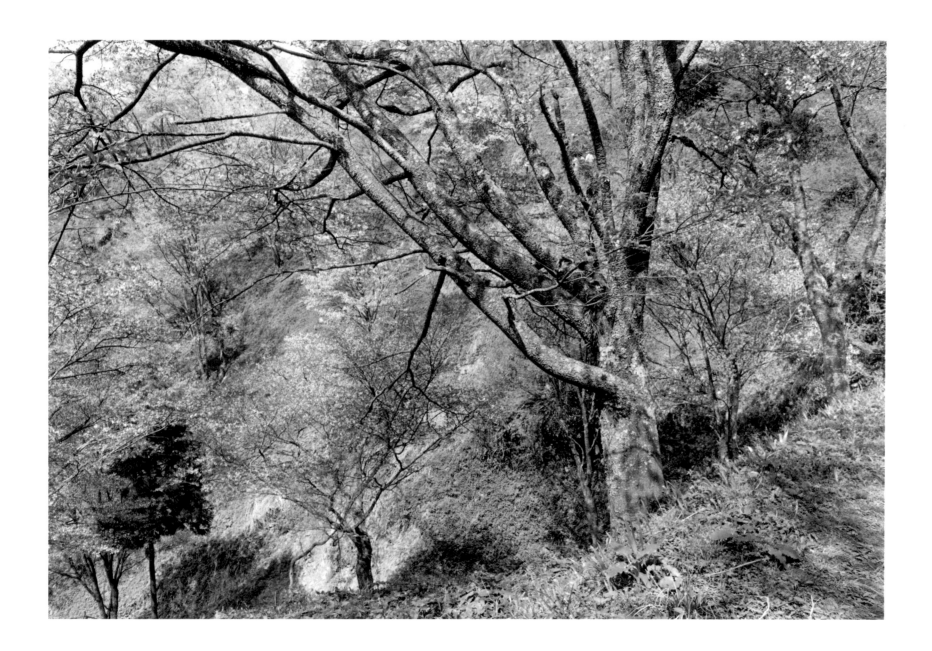

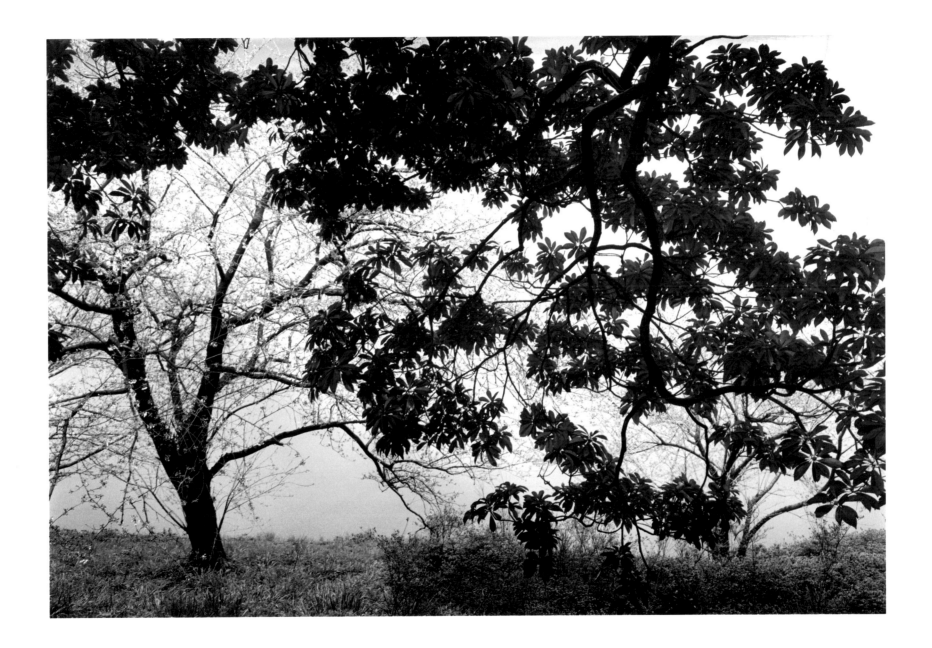

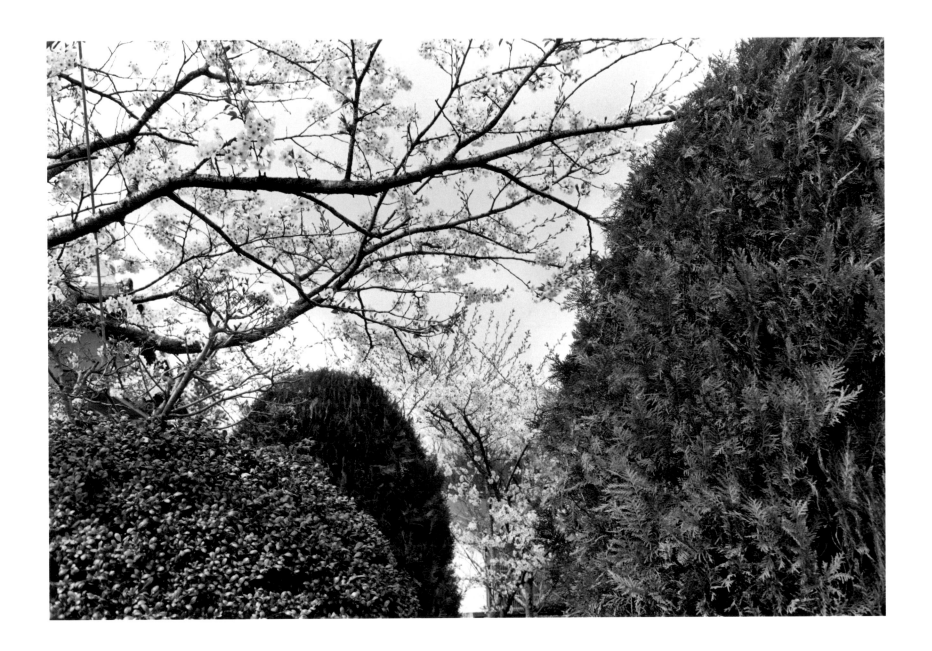

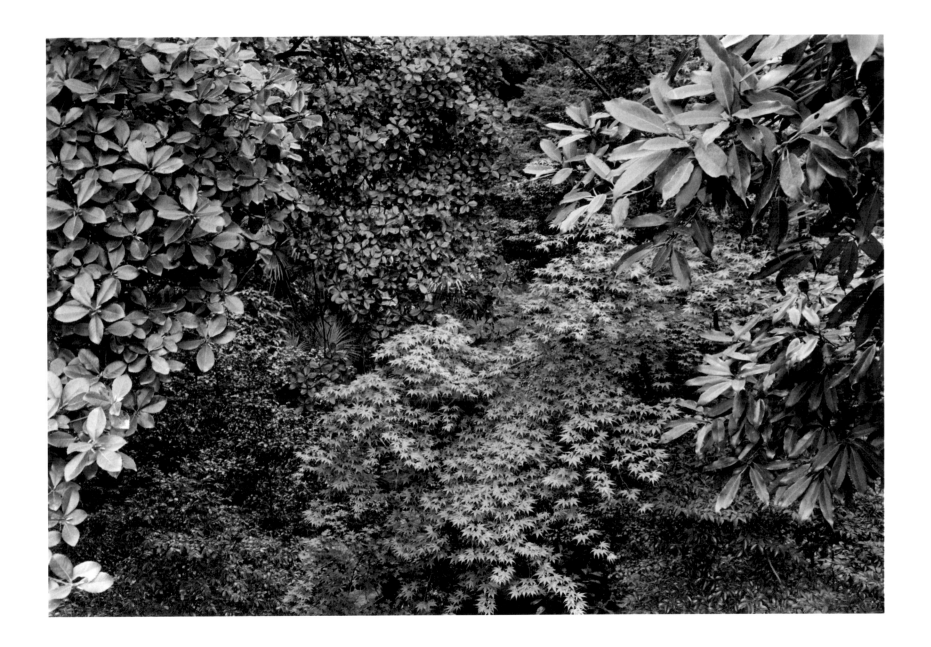

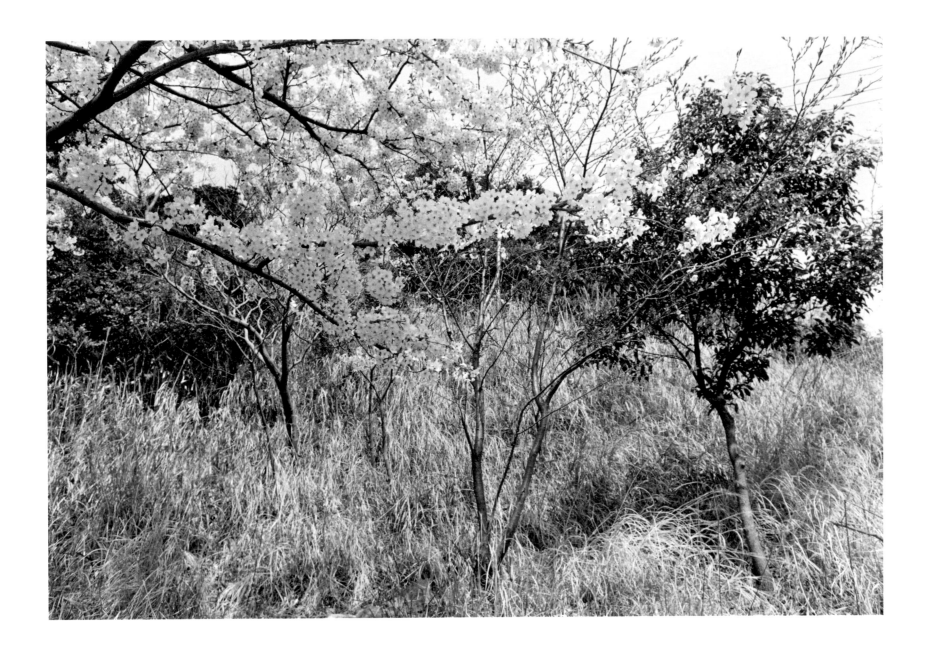

28

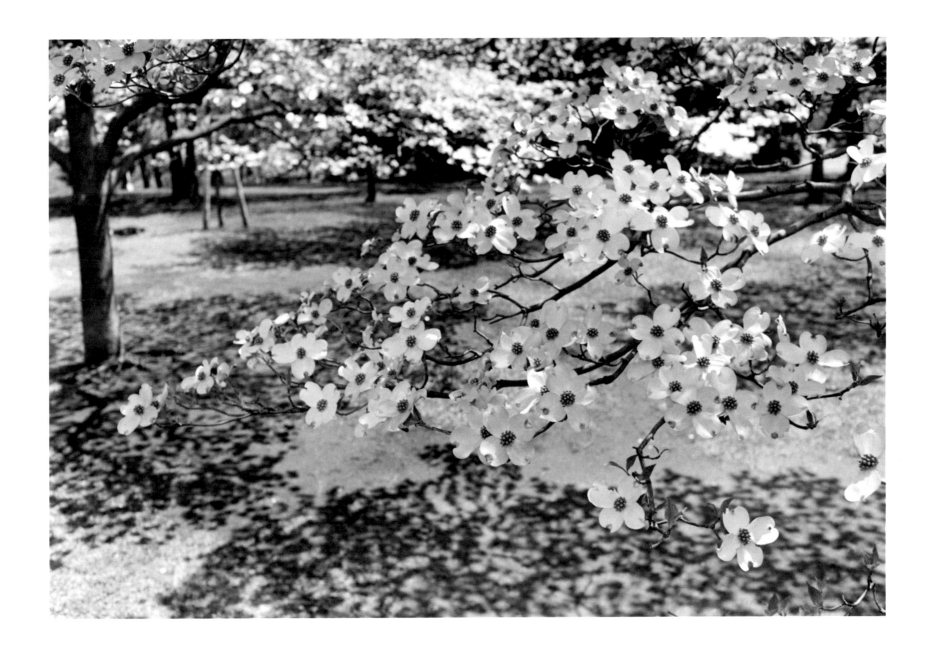

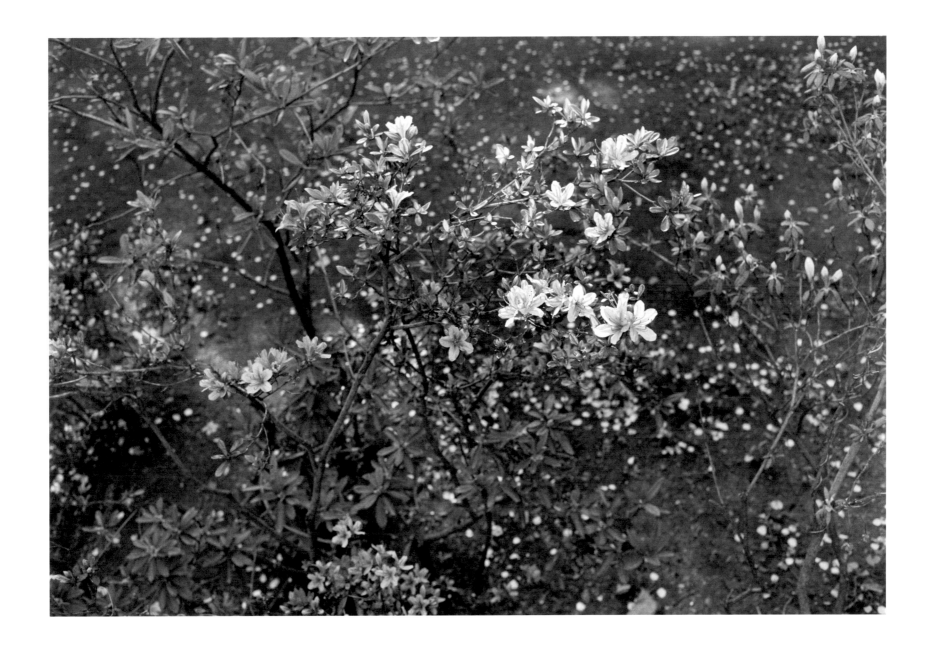

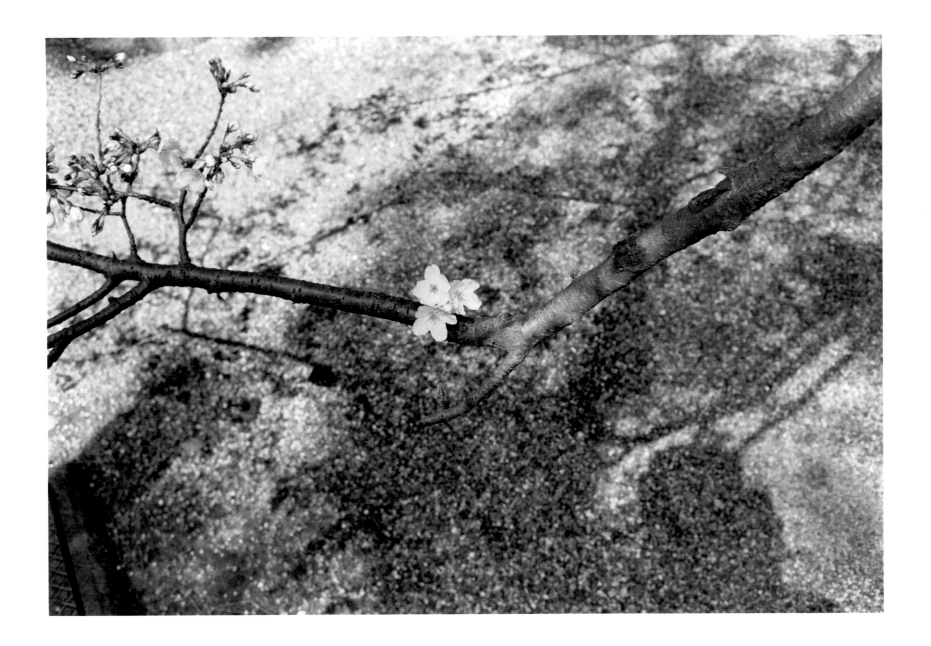

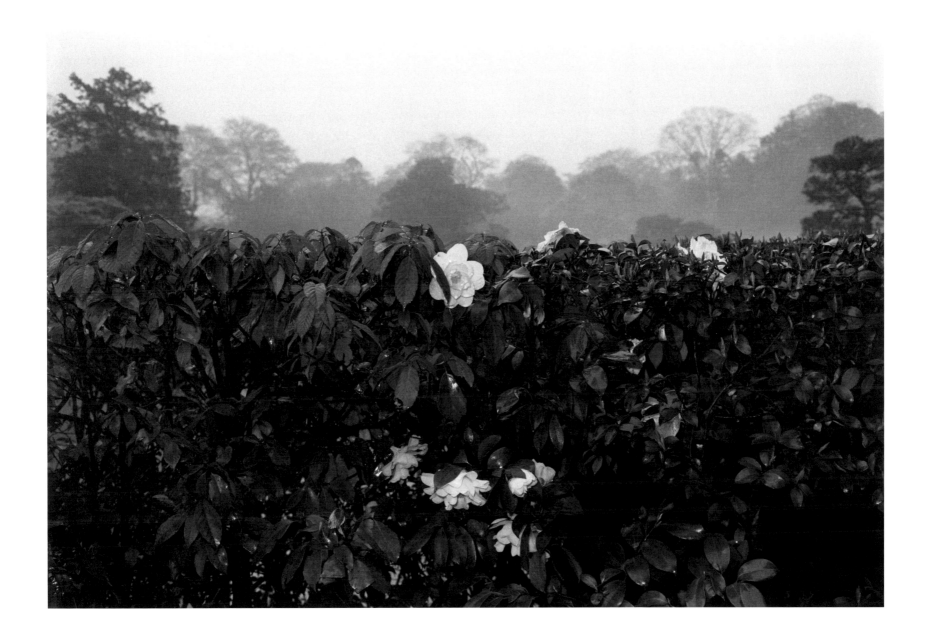

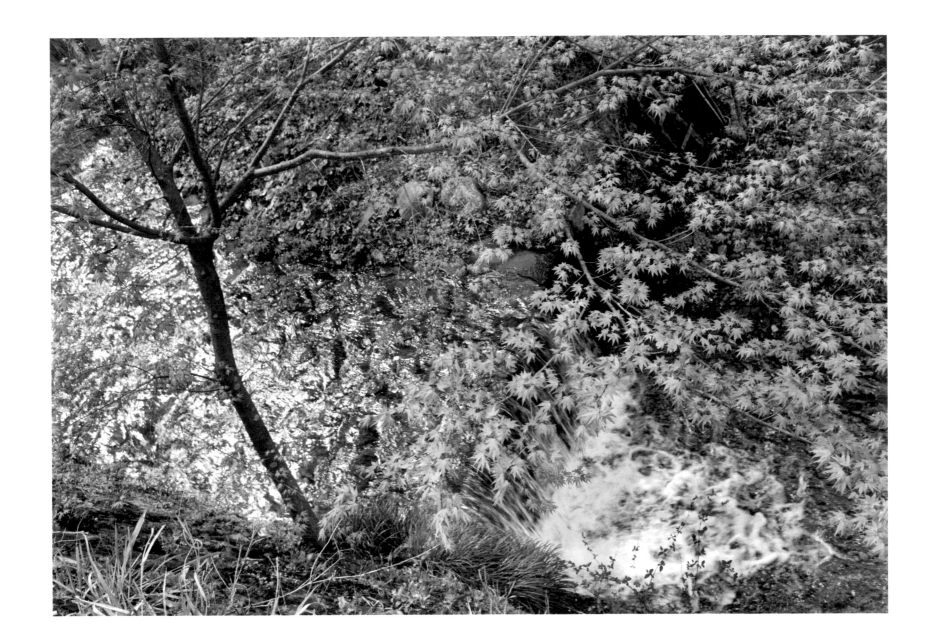

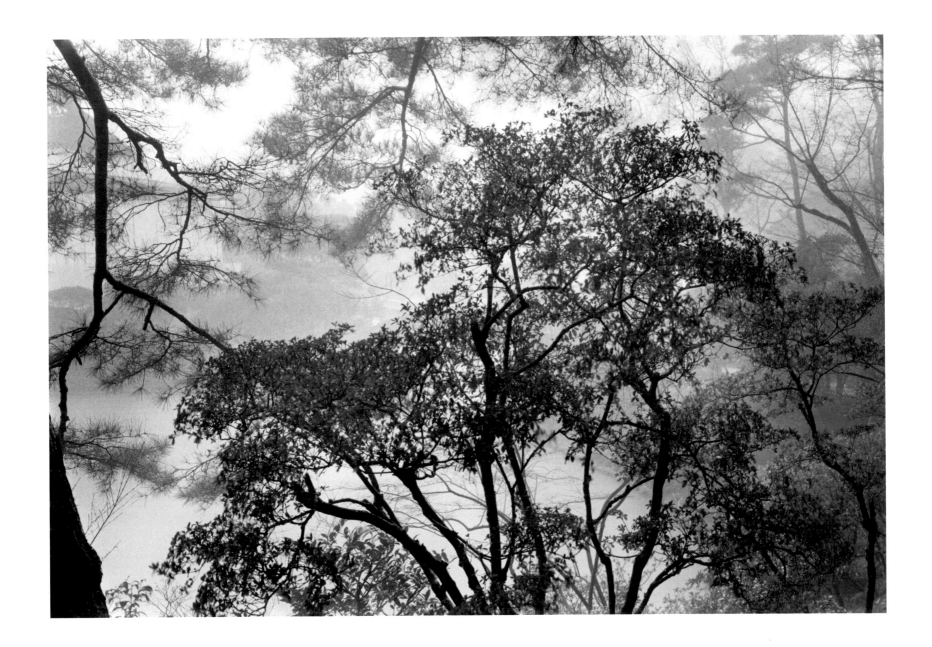

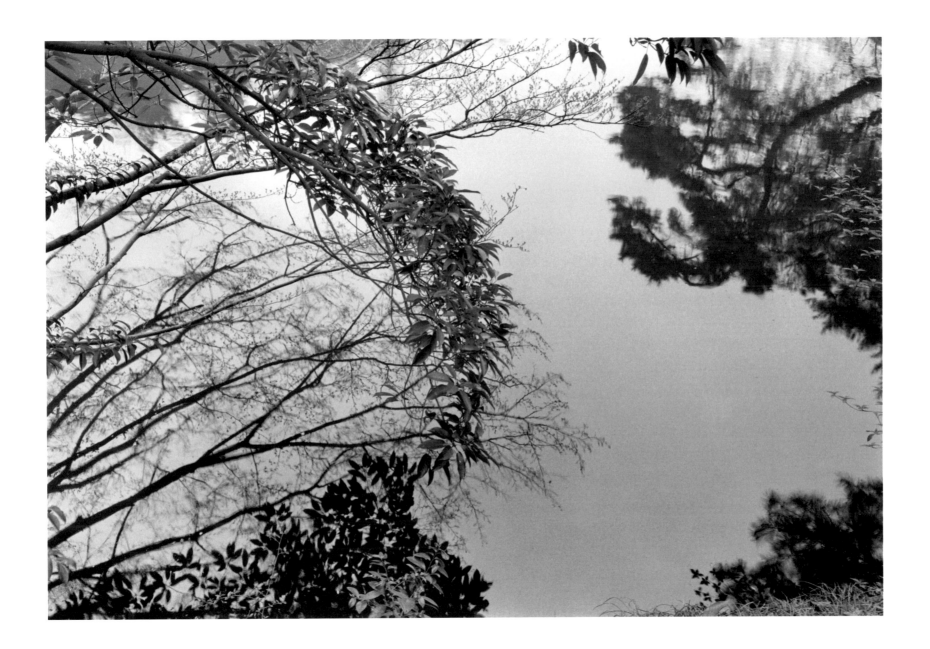

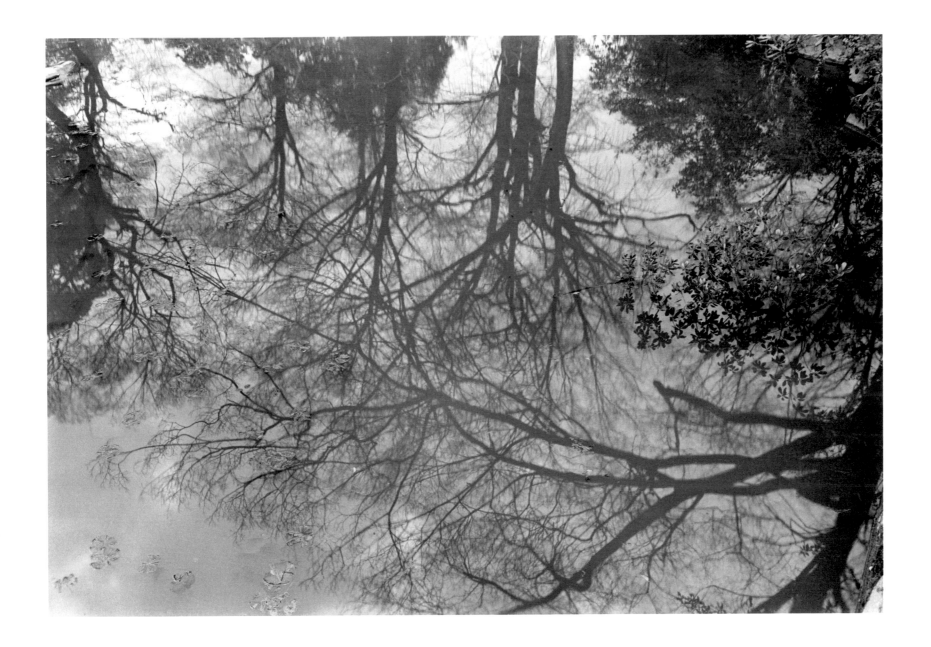

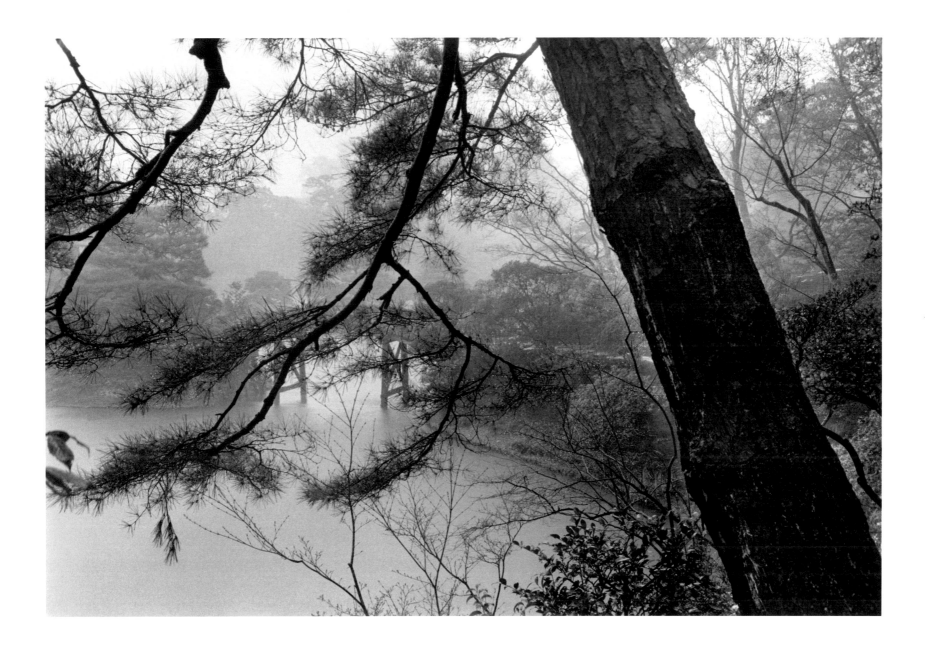

I first went to Japan in 1977 and found the whole country ablaze with blossom.

I went again in 1979, 1981, and 1984, always at cherry blossom time.

As far as I knew, Japan was always abloom. —LF

All photographs © 2006 Lee Friedlander Publication © 2006 Fraenkel Gallery 49 Geary Street San Francisco, CA 94108 Tel 415.981.2661 Fax 415.981.4014 www.fraenkelgallery.com
ISBN 978-1-881337-20-1 Distributed by D.A.P./Distributed Art Publishers, Inc. 155 Sixth Avenue, 2nd floor New York, NY 10013 Tel 212.627.1999 Fax 212.627.9484 www.artbook.com
Calligraphy: Shuntei Taniguchi Design: Katy Homans Separations: Thomas Palmer Printing: Danny Frank, Meridian Printing All rights reserved. This book may not be reproduced in whole or in part,
in any form (beyond copying permitted by Sections 107 and 108 of the United States Copyright Law, and except by reviewers for the public press), without written permission from Fraenkel Gallery

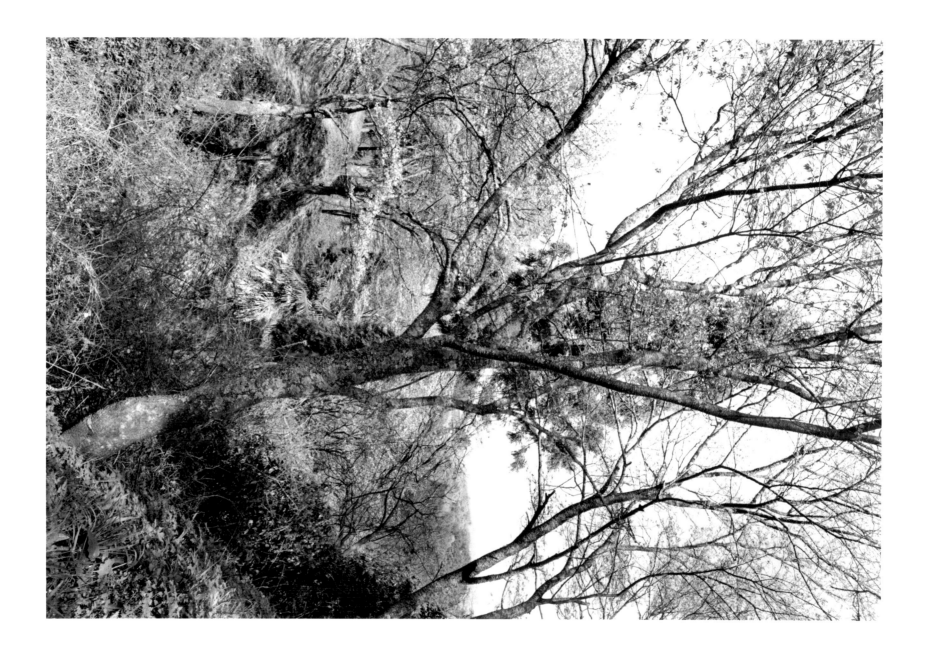

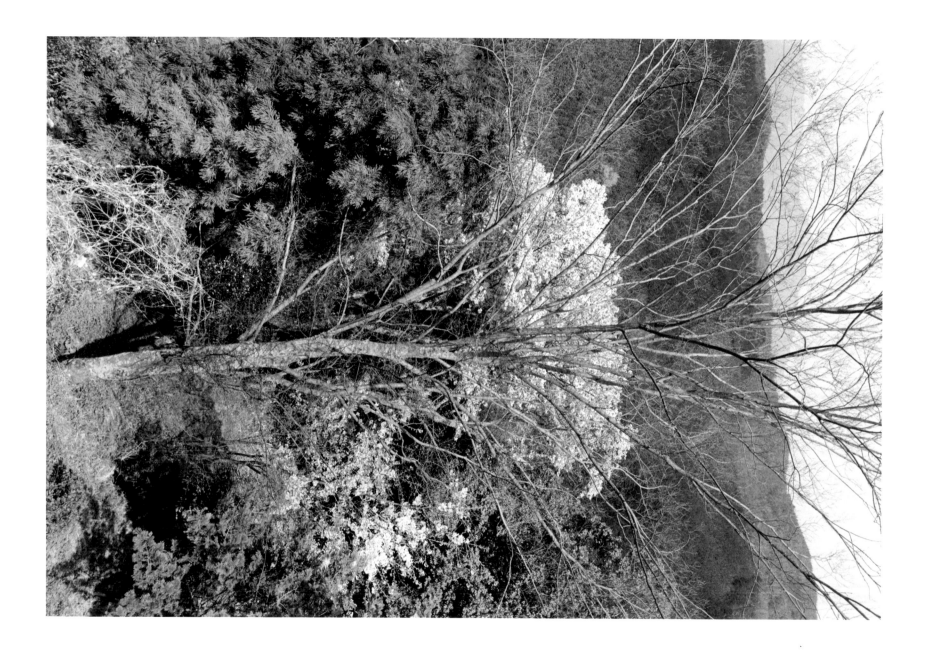

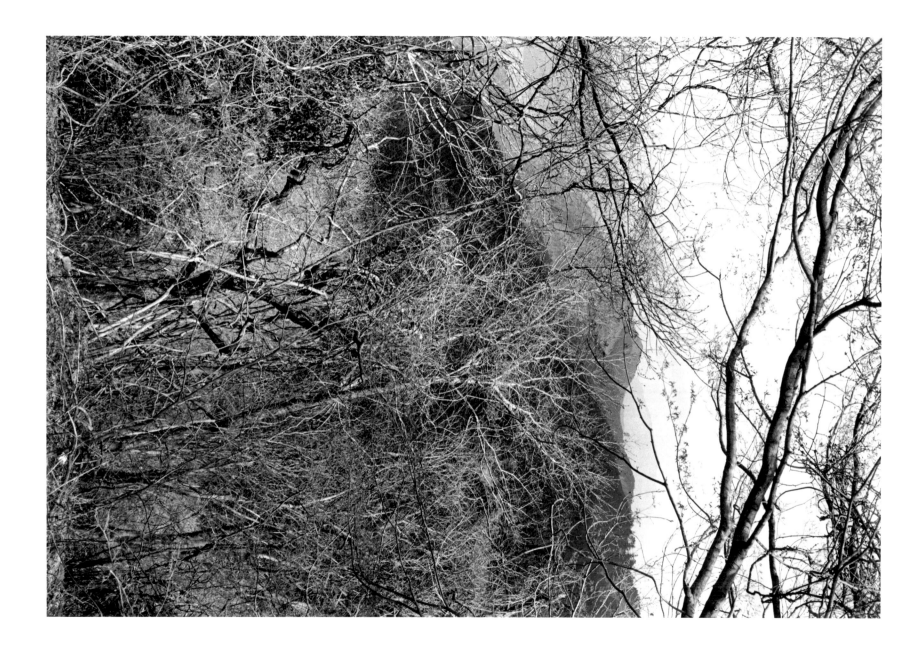

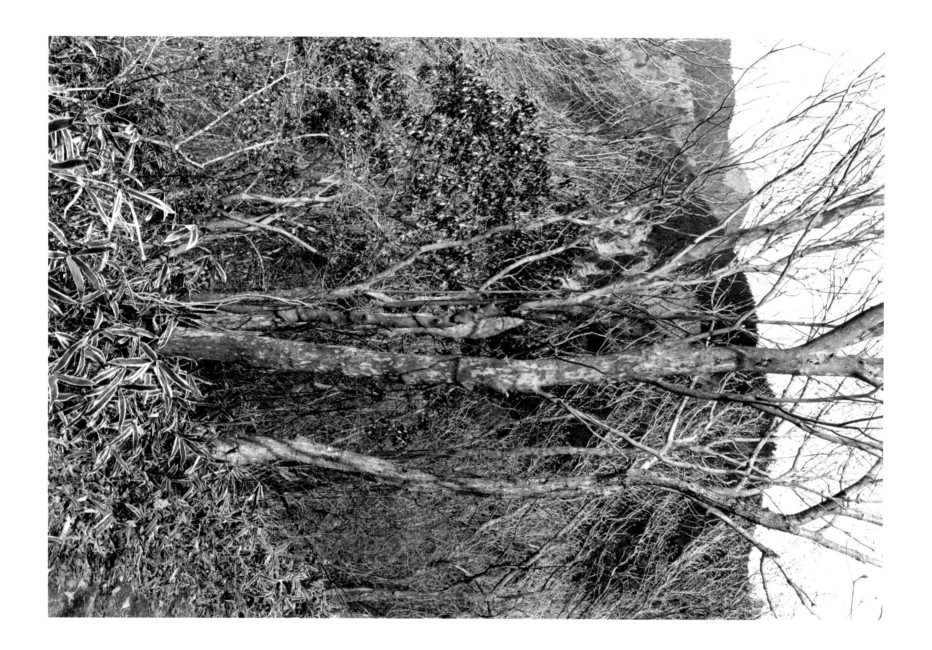

41

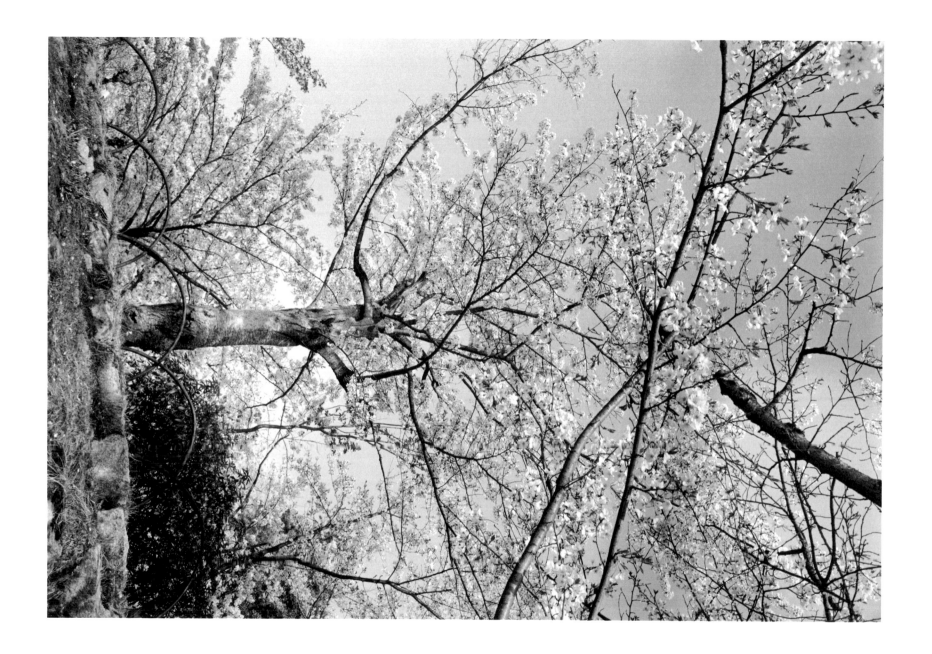

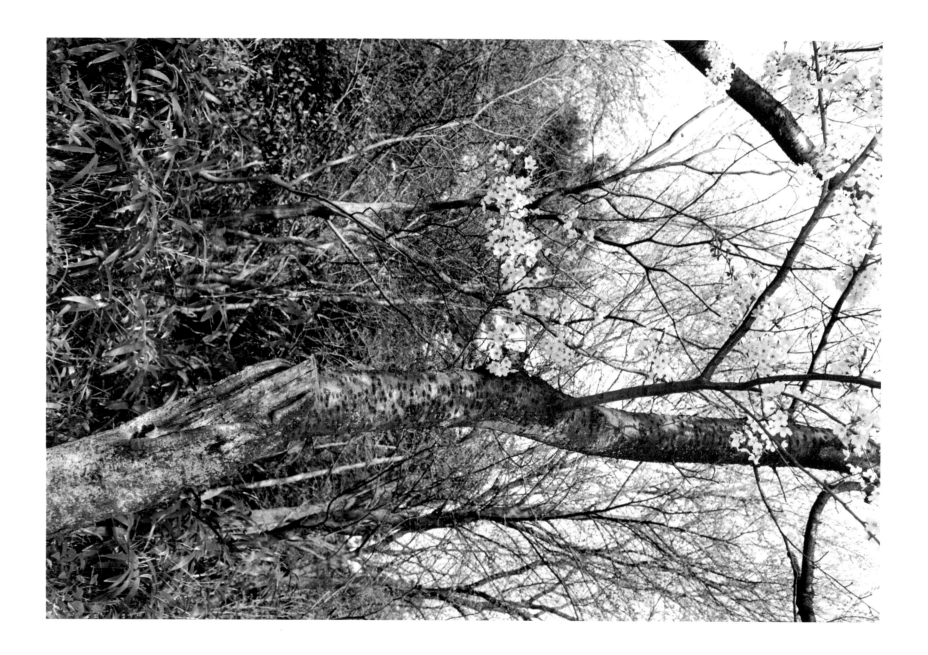

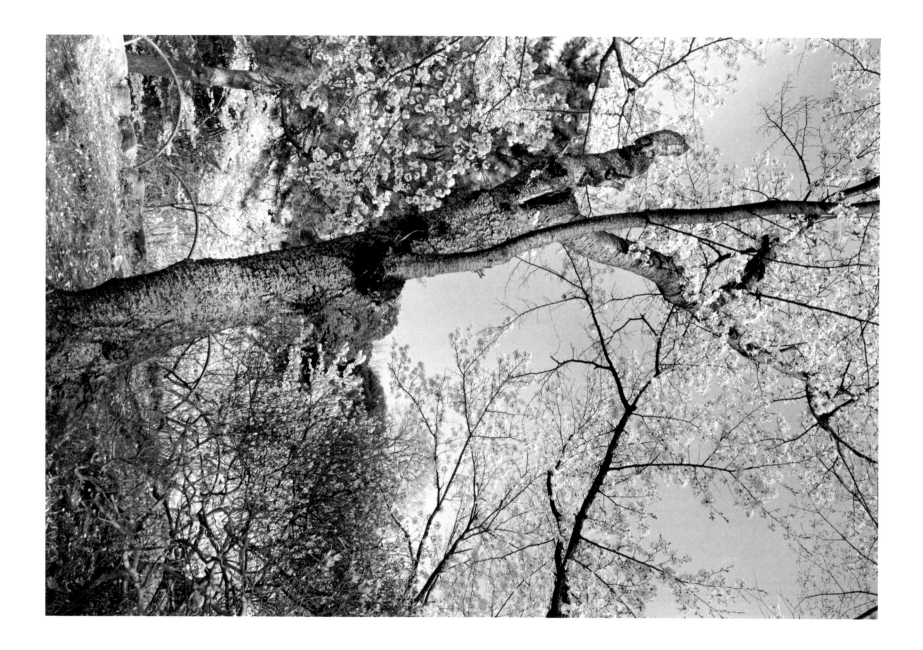

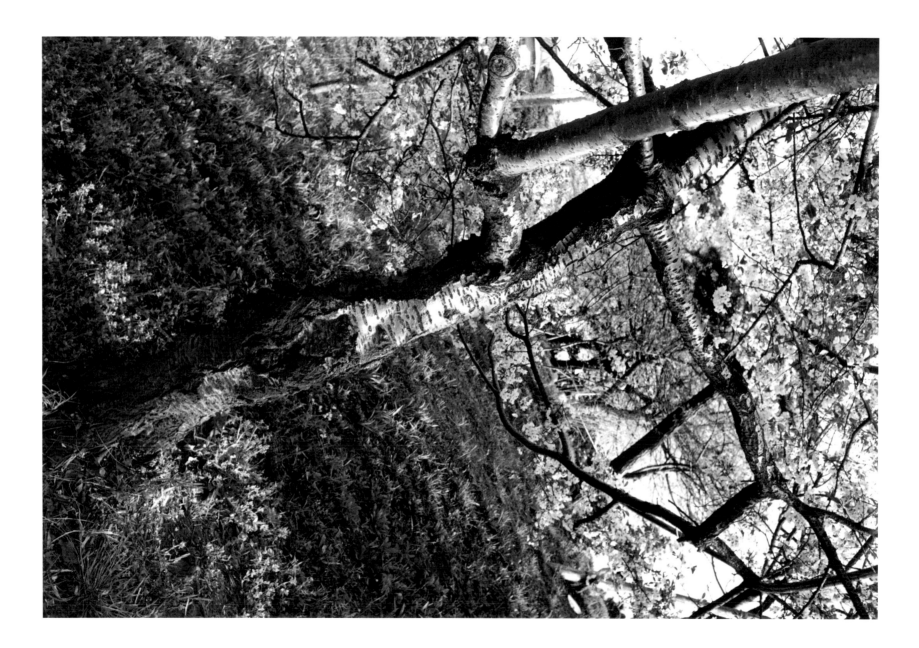

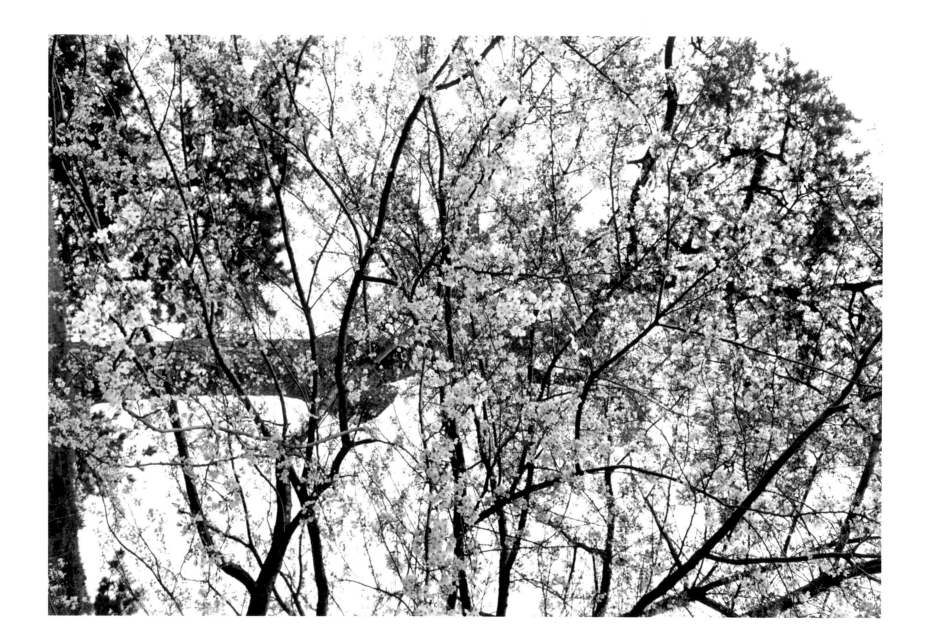

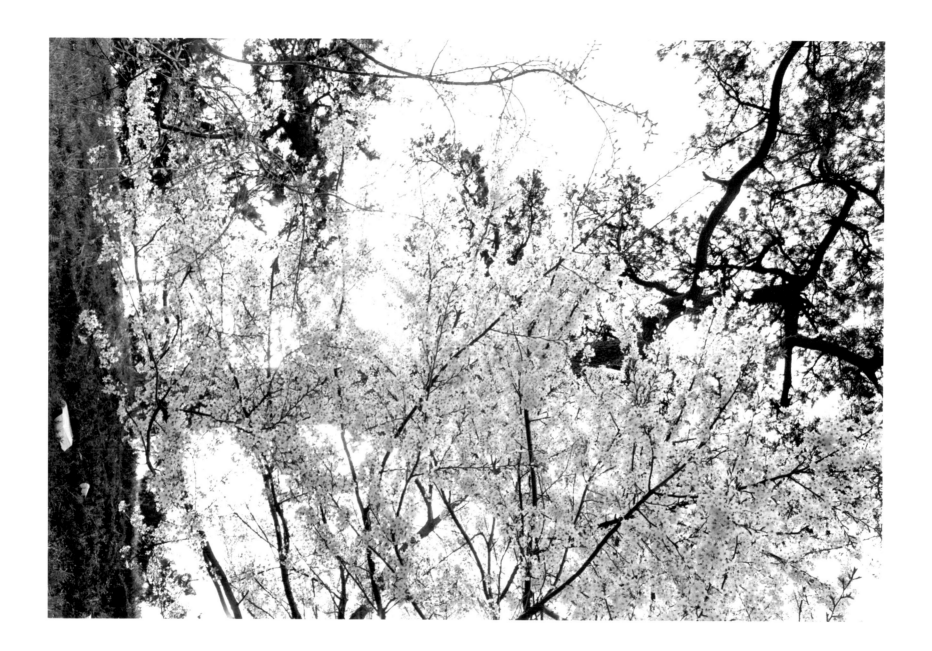

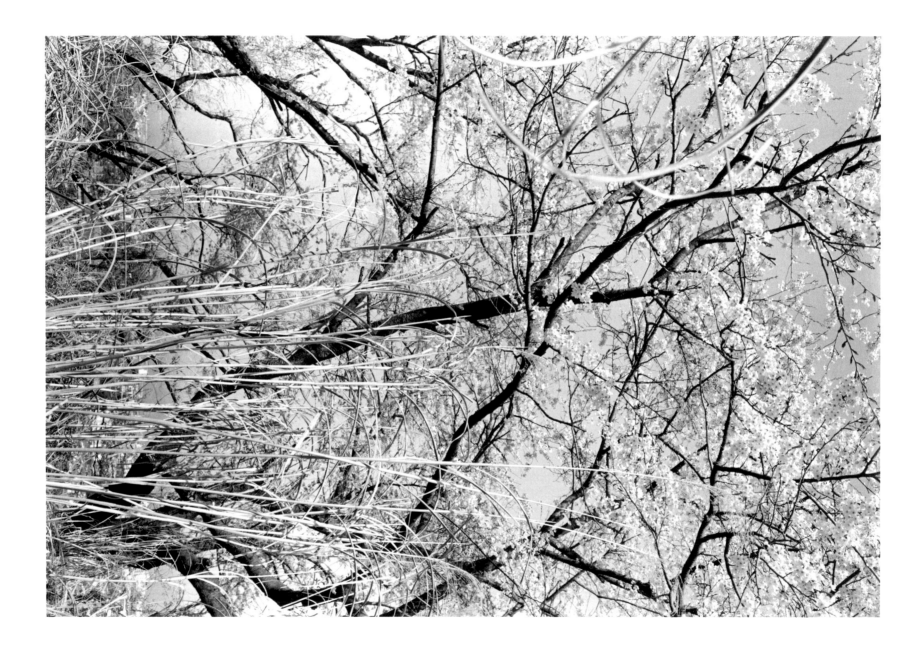

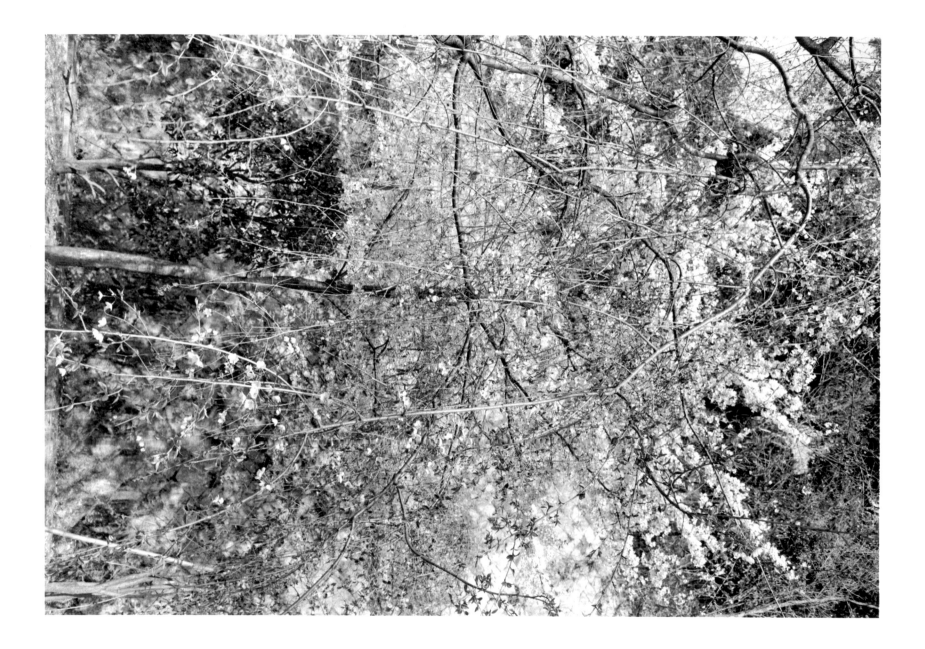

49

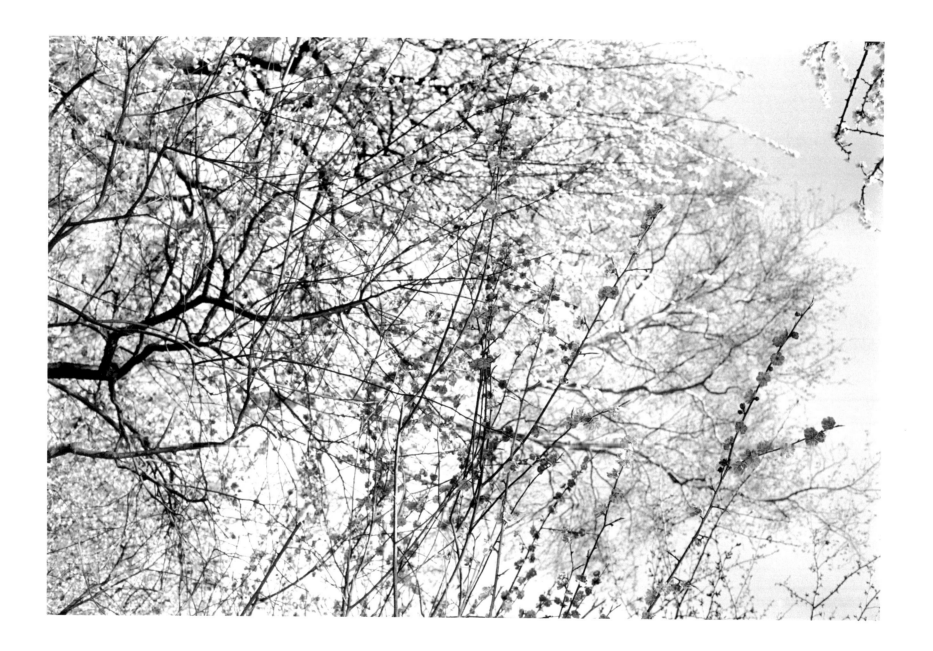

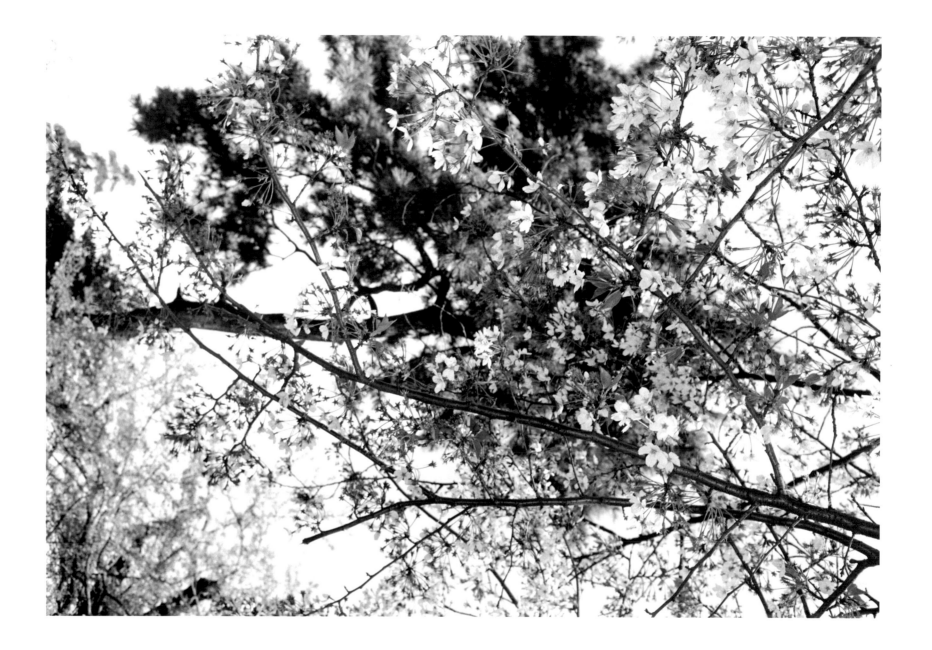

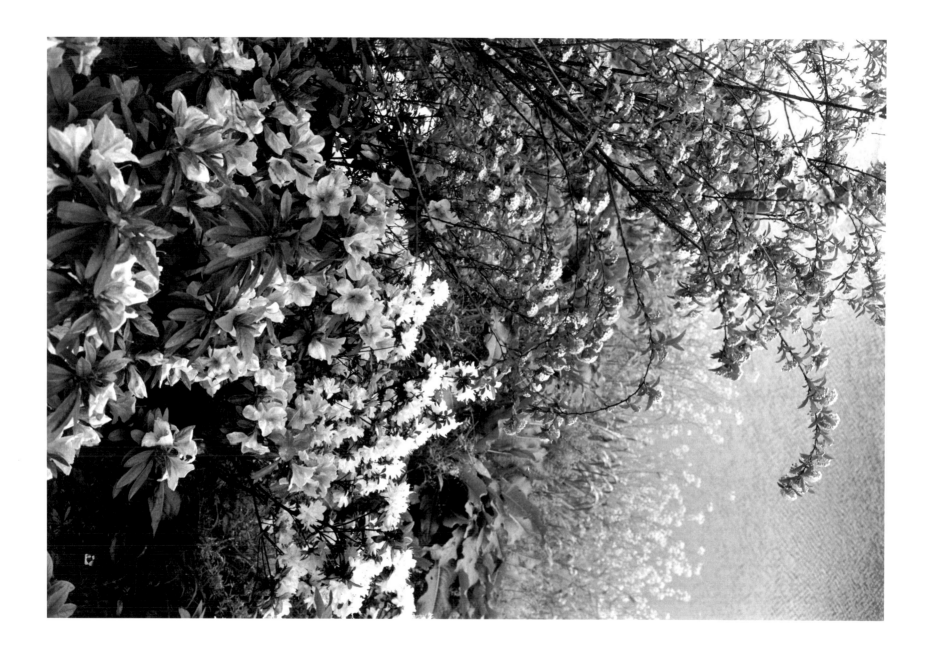

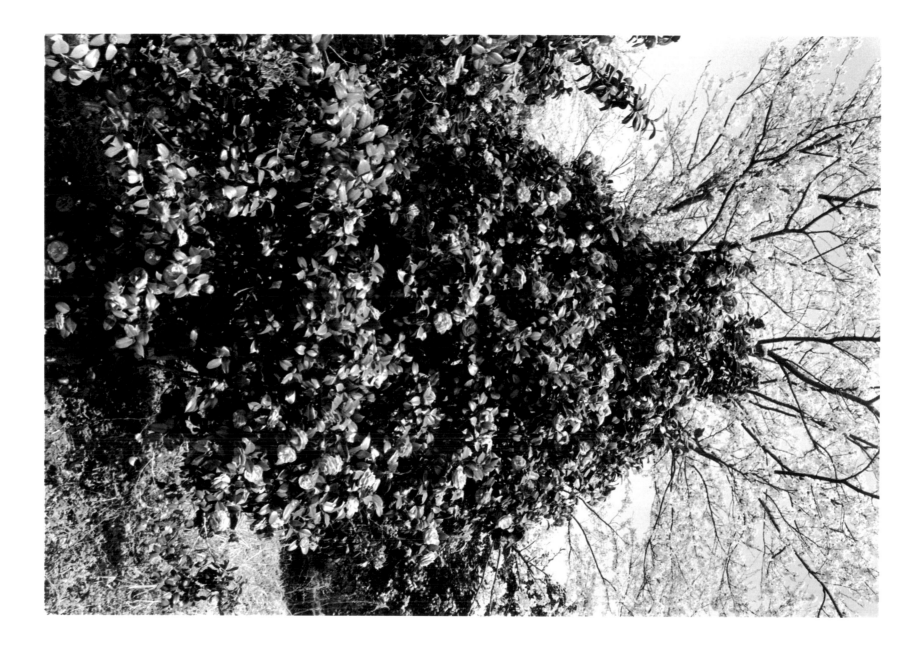

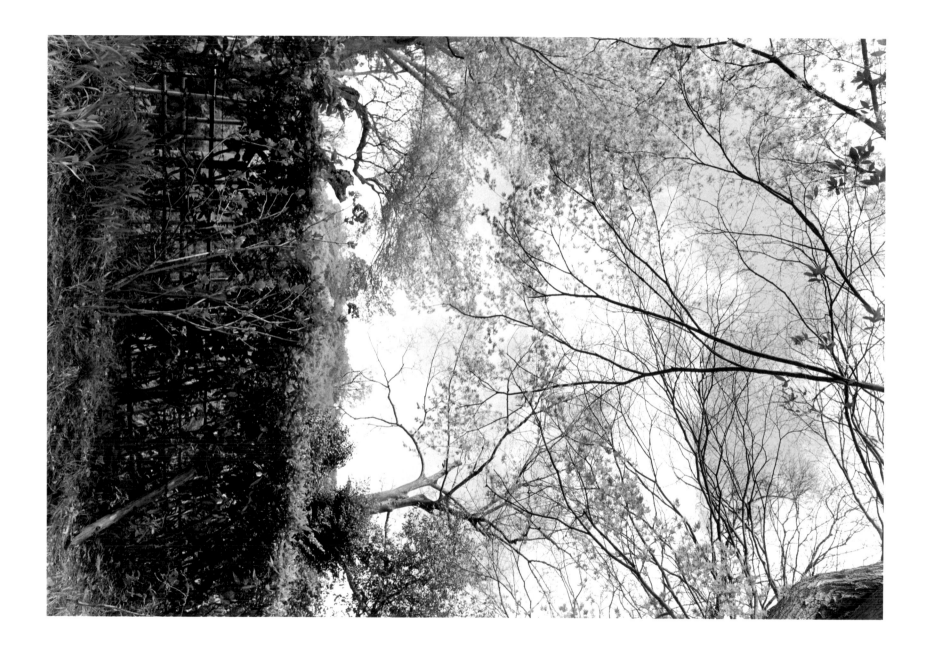

54

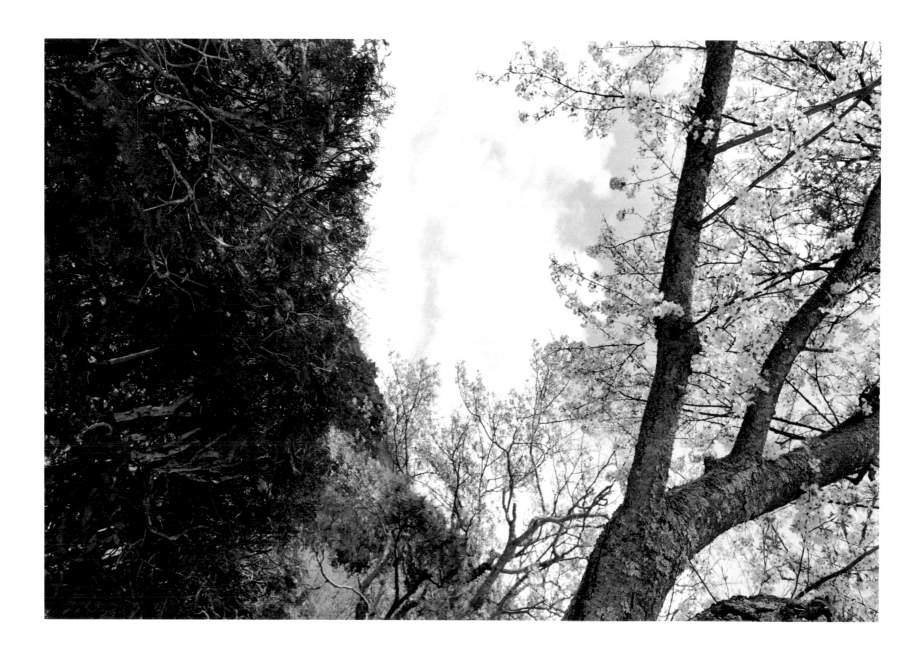

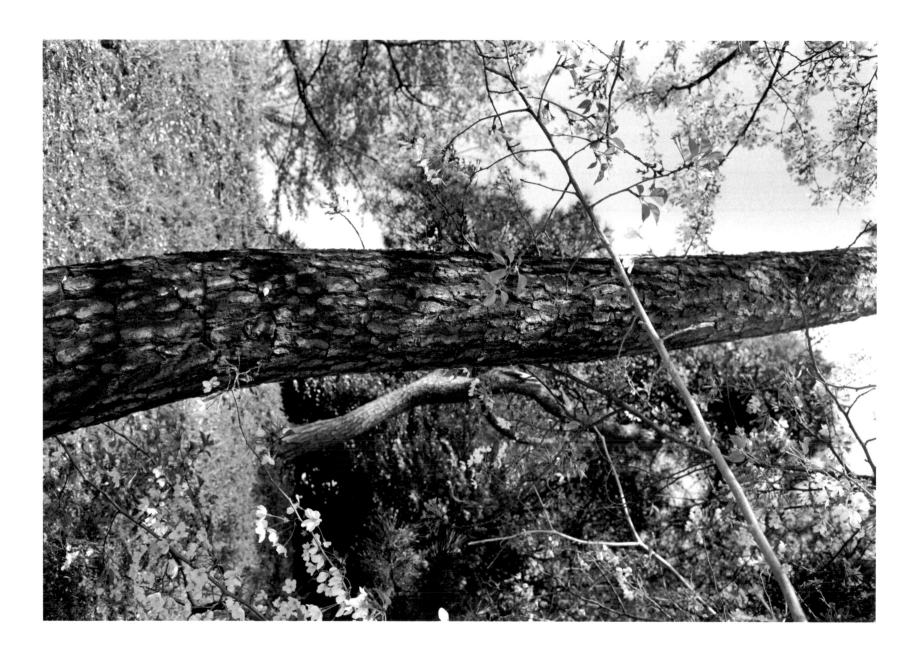

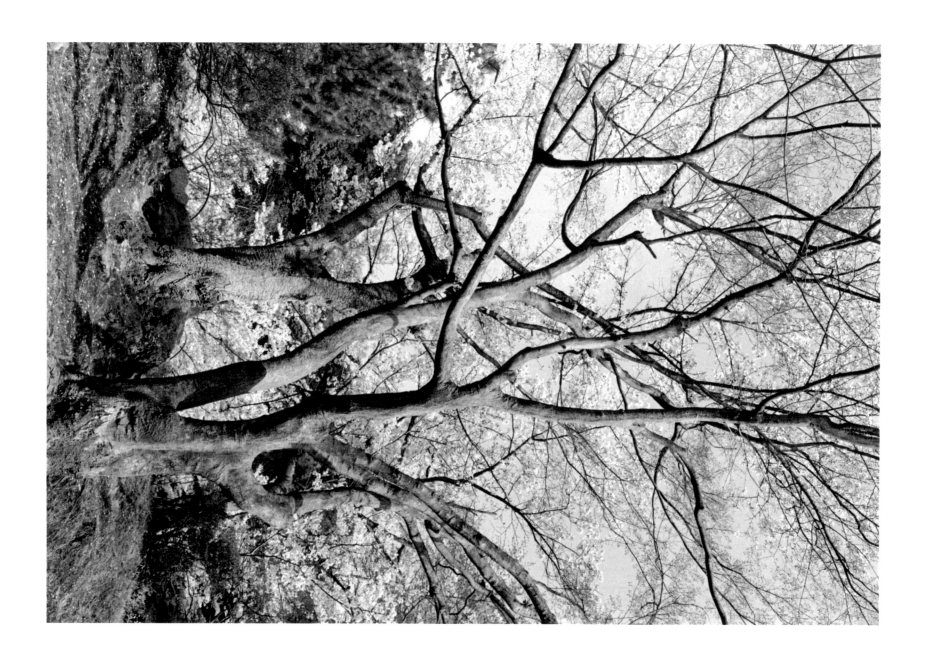

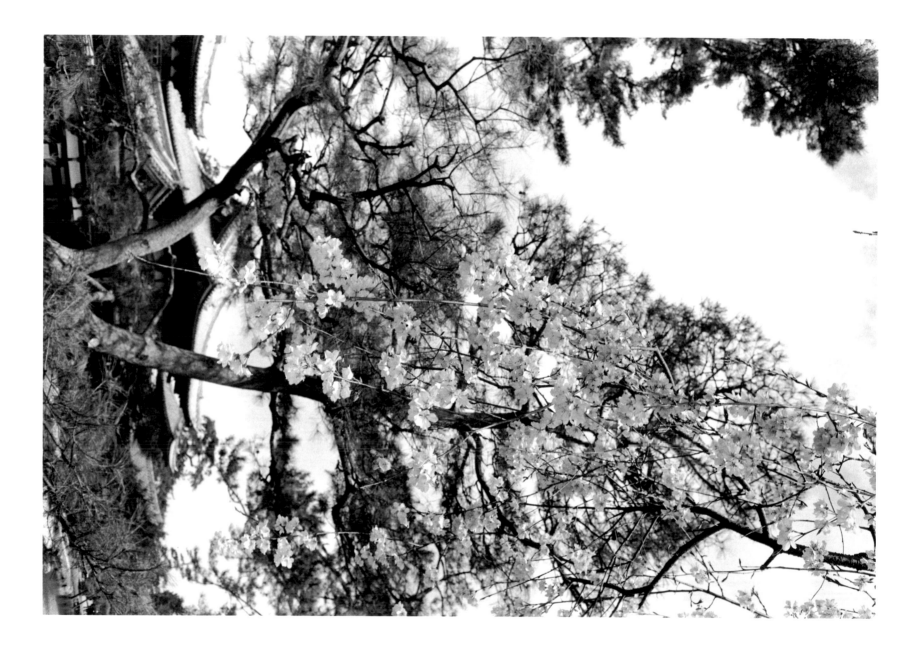

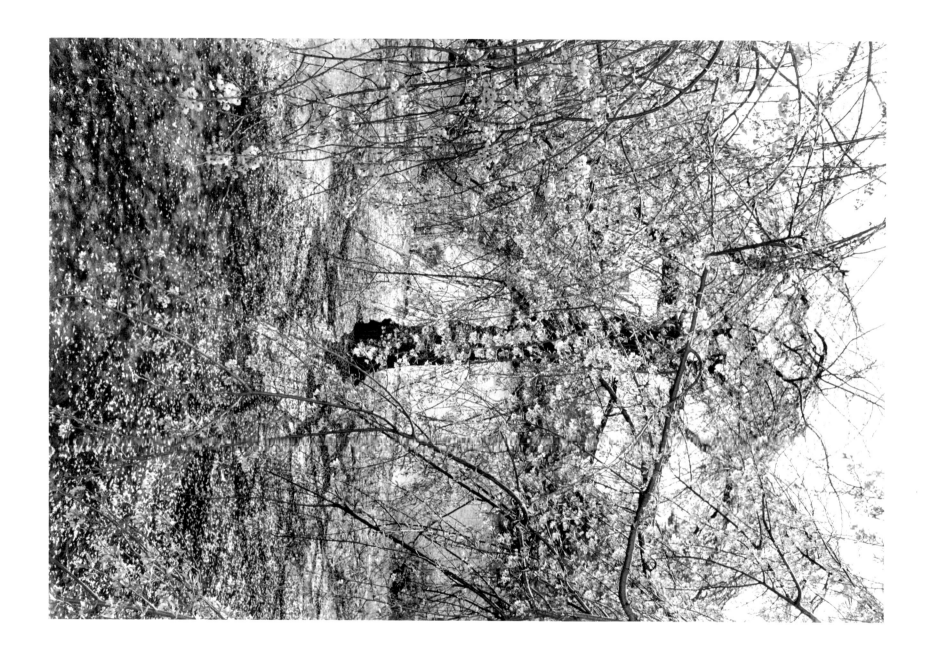

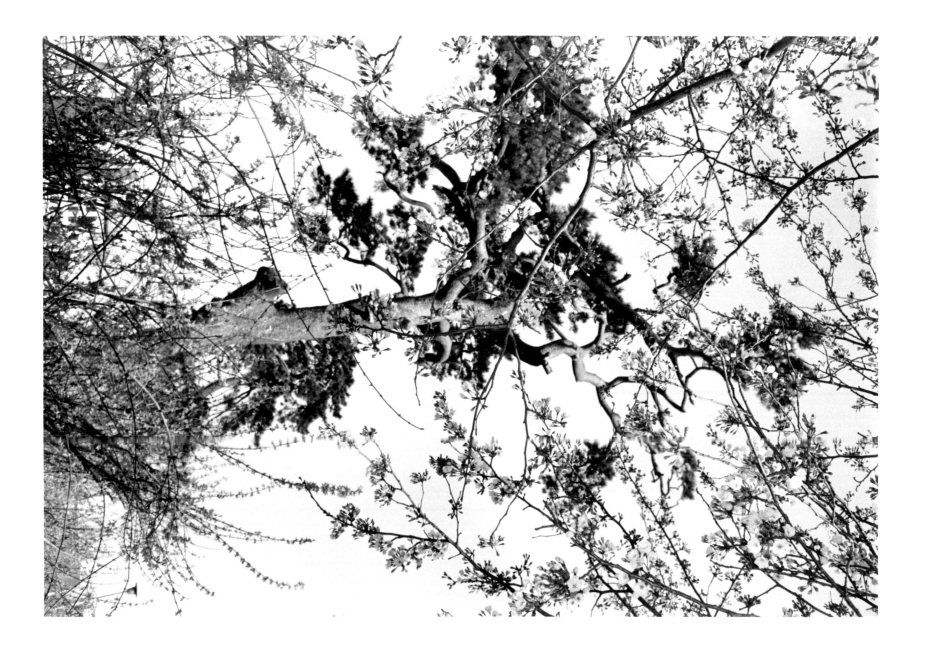

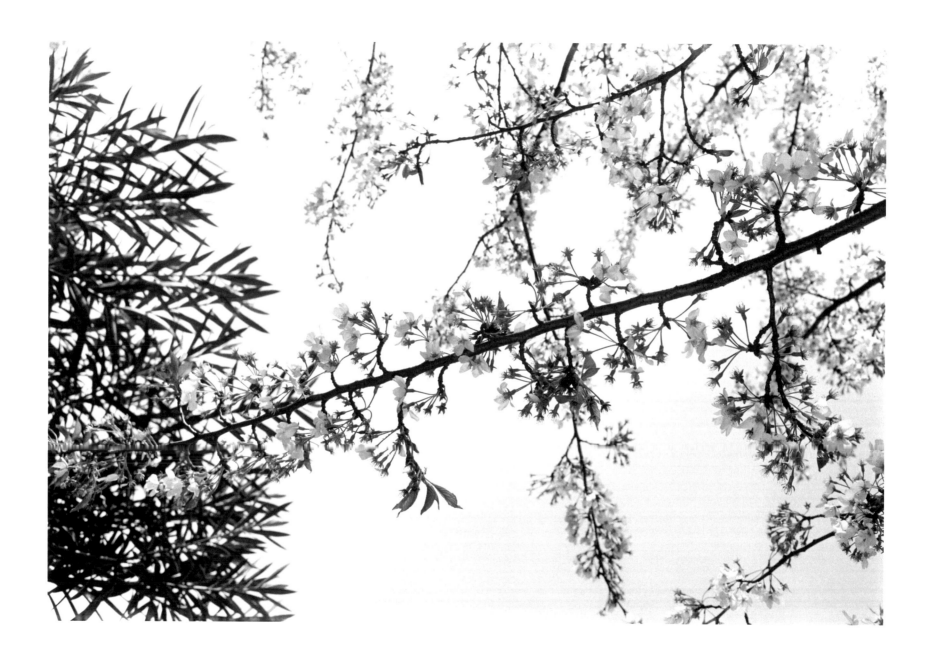

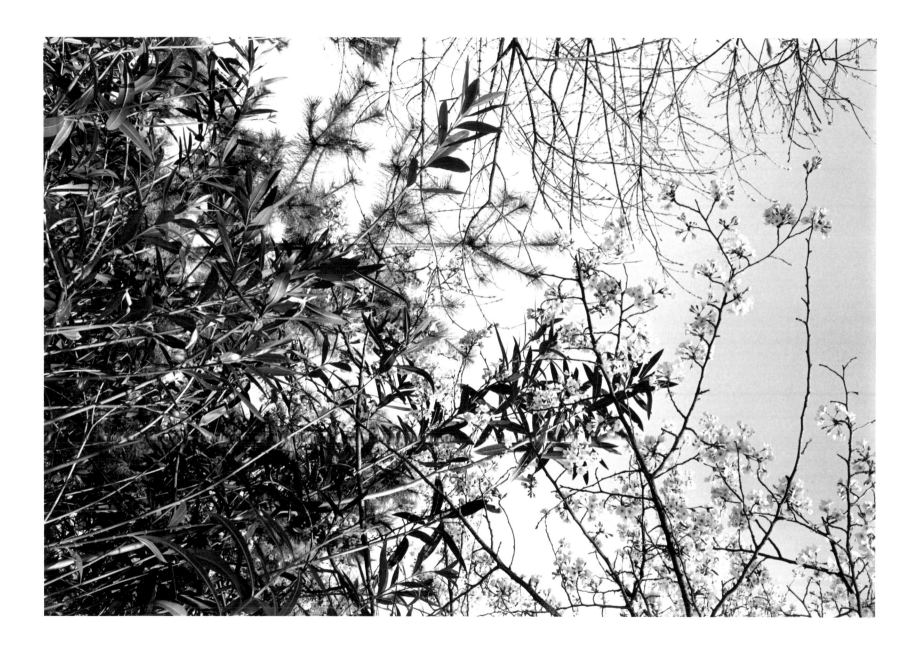

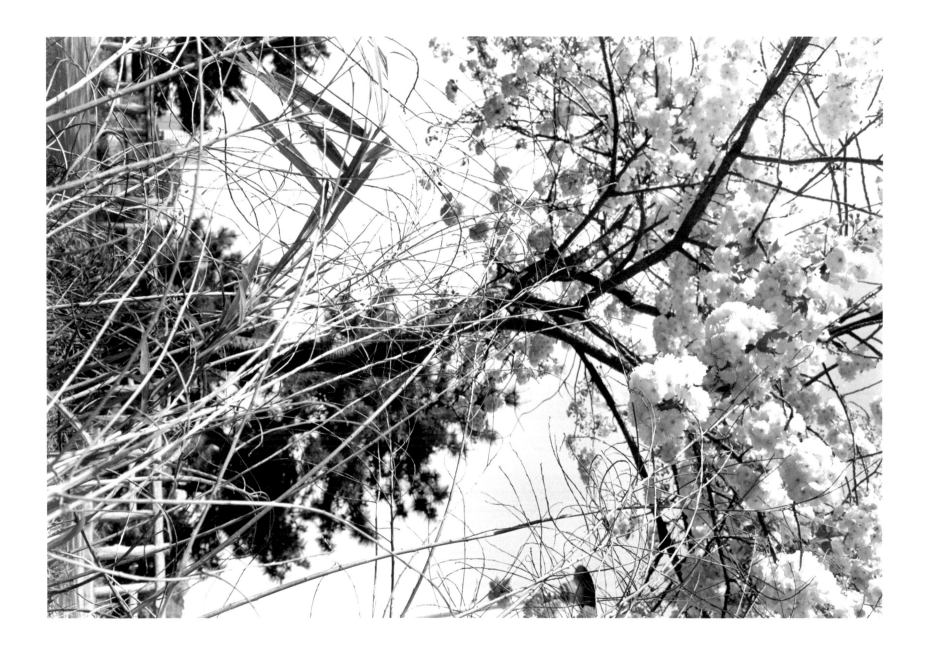

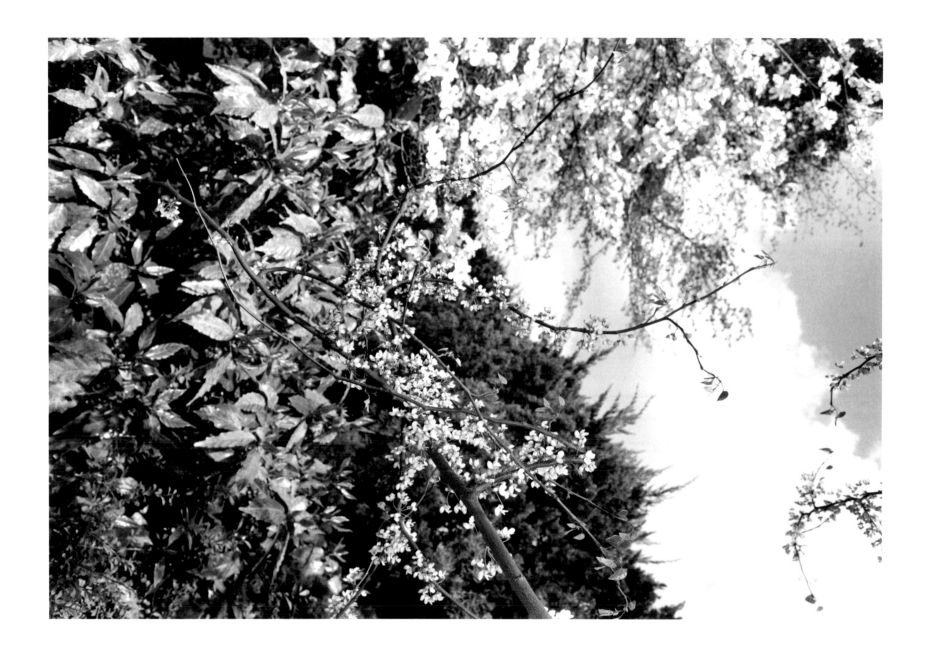

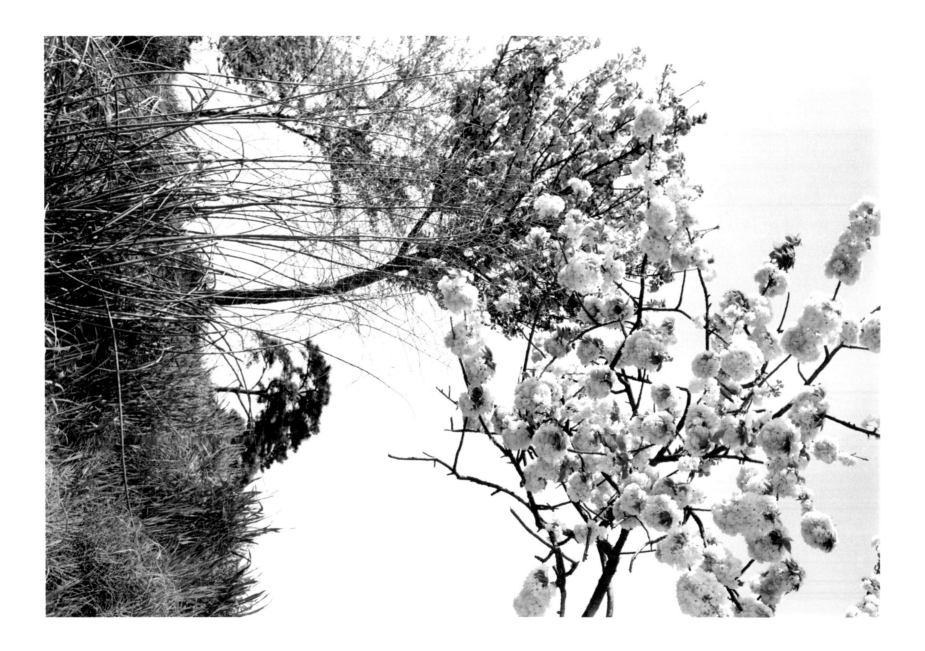

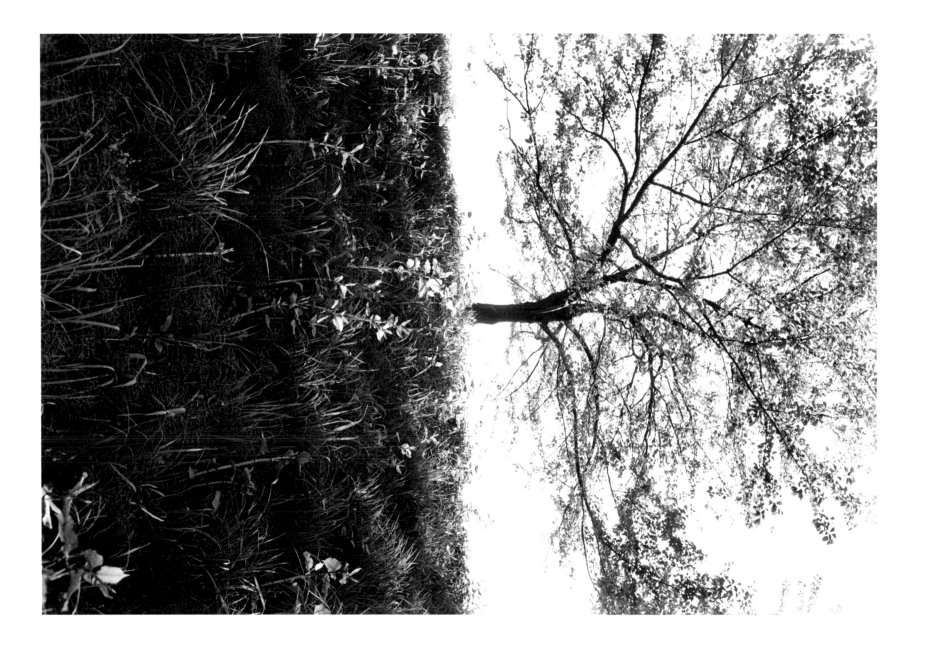

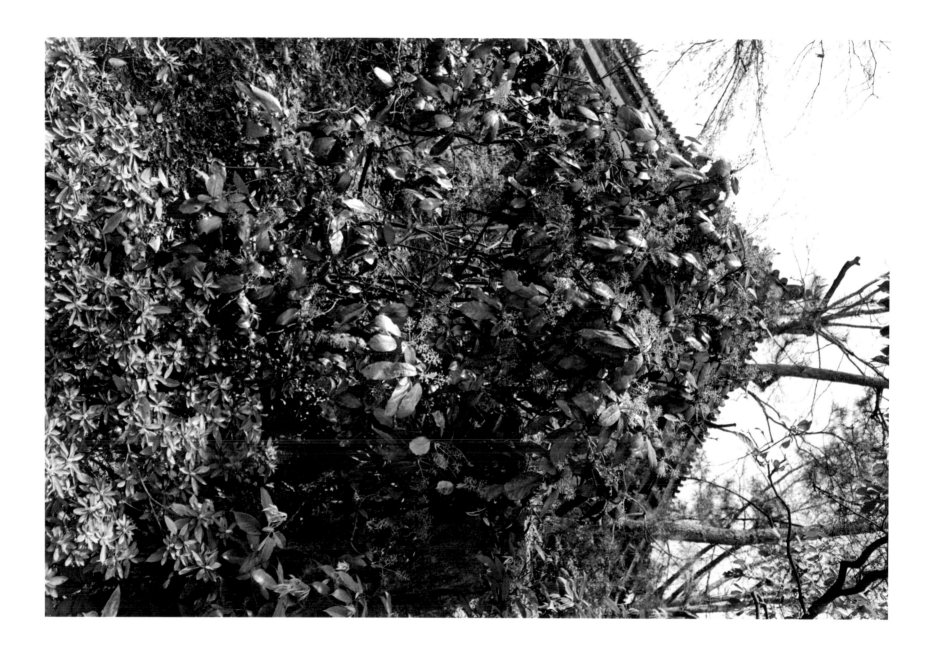

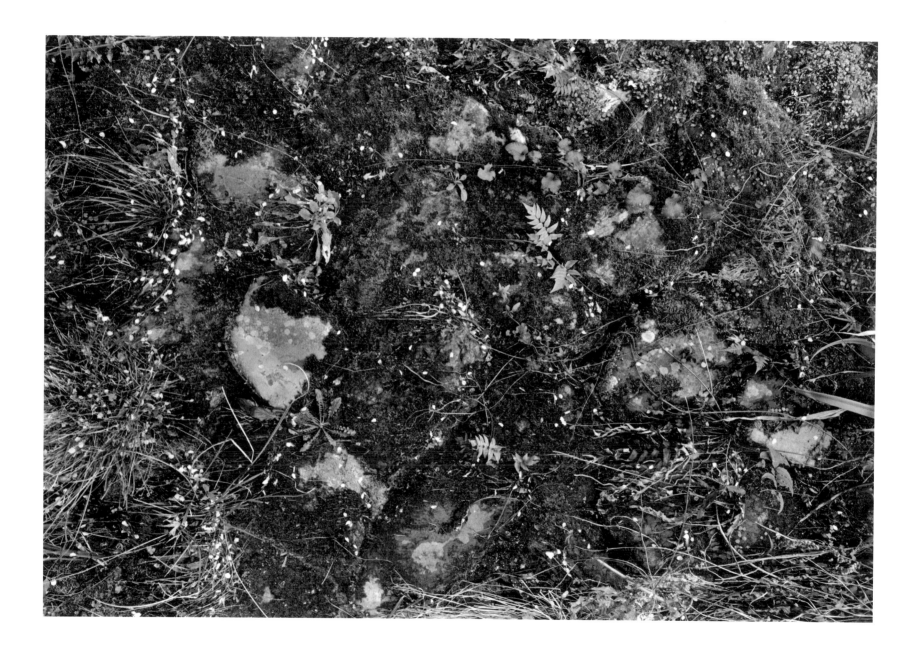

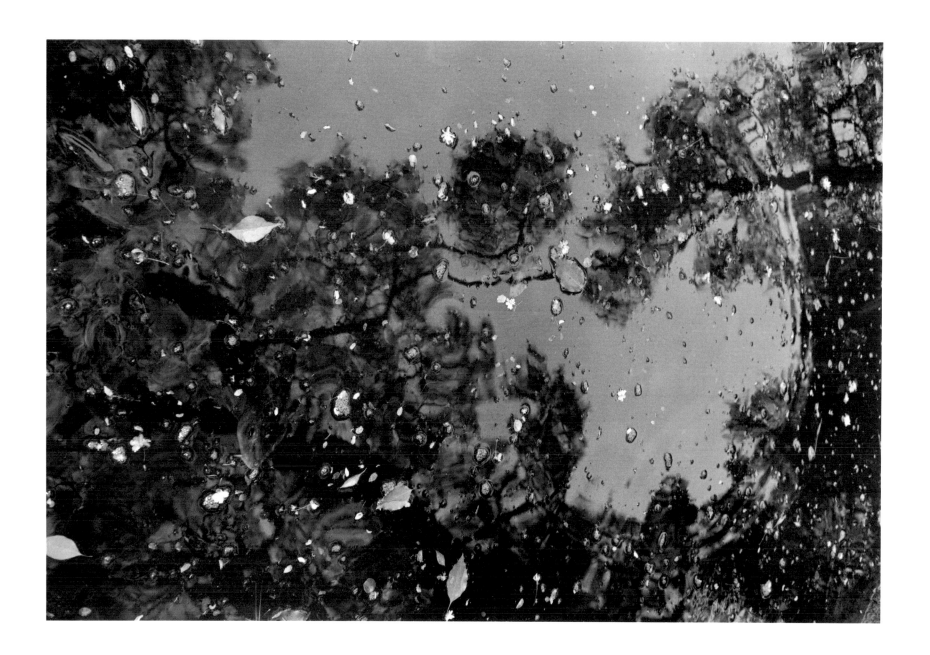

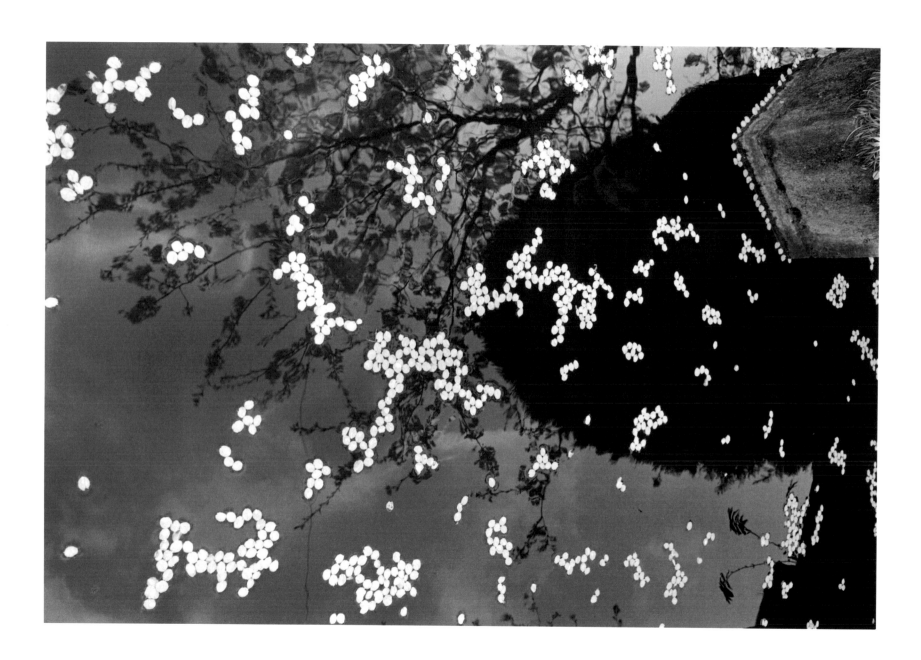

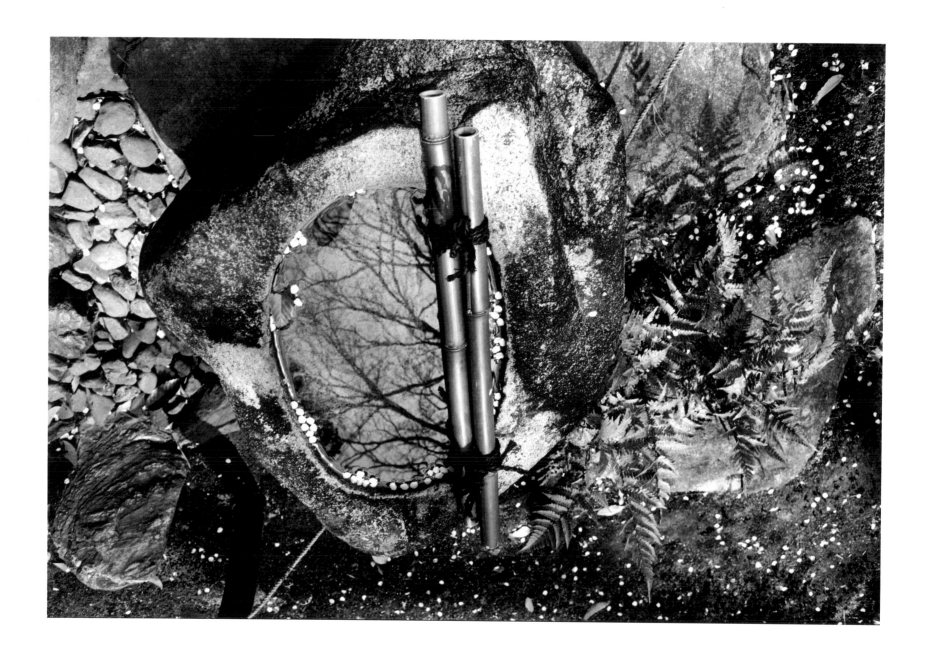

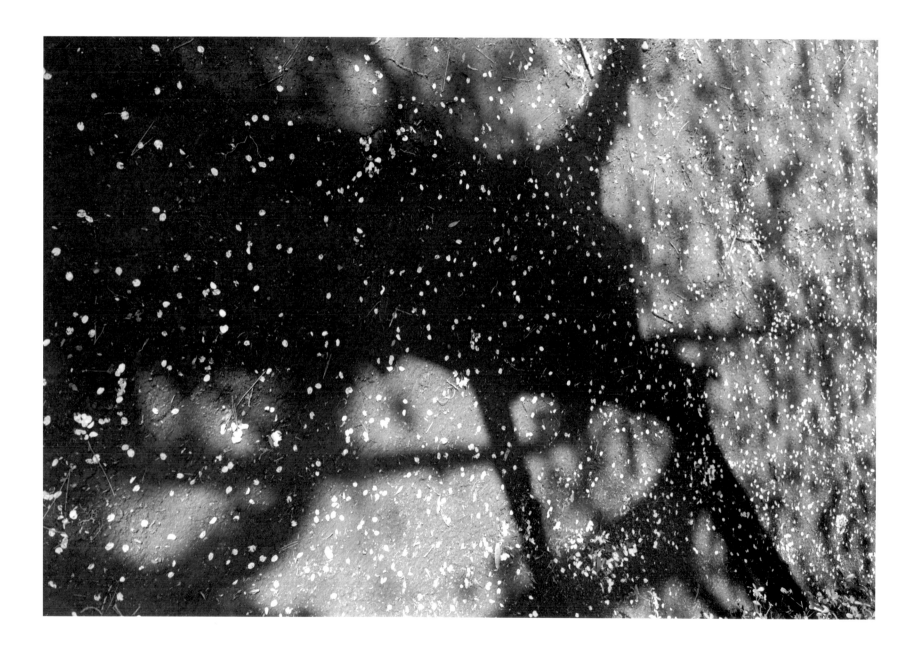

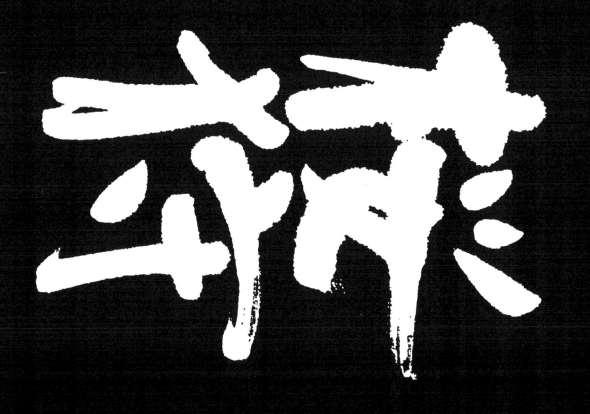

CHERRY BLOSSOM TIME IN JAPAN THE COMPLETE WORKS

LEE FRIEDLANDER

FRAENKEL GALLERY